OVER MY
DEAD BODY

OVER MY DEAD BODY

The Sensational Age of the American Paperback : 1945-1955

LEE SERVER

CHRONICLE BOOKS SAN FRANCISCO, CA

This book is for Elizabeth Server and Terri Hardin

Printed in Hong Kong.

Editing: Carey Charlesworth
Book and cover design: Tom Morgan, Blue Design

Library of Congress Cataloging-in-Publication Data

Server, Lee.
 Over my dead body : the sensational age of the American paperback, 1945-1955 / by Lee Server.
 p. cm.
 ISBN: 0-8118-0550-6 (PB) 0-8118-0646-4 (HC)
 1. Paperbacks--Publishing–United States–History–20th century.
 2. Literature publishing–United States–History–20th century.
 3. Popular literature–United States–History and criticism.
 4. Books and reading–United States–History–20th century.
 5. American fiction–20th century–History and criticism.
 I. Title.
 Z479.S39 1994
 070.5'73'0973–dc20
Distributed in Canada by Raincoast Books,
112 East Third Avenue, Vancouver, B.C. V5T 1C8

10 9 8 7 6 5 4 3 2 1

Chronicle Books
275 Fifth St.
San Francisco, CA 94103

Page Two: *Rudolph Belarski had spent many years painting covers for the pulps before he became a regular paperback cover artist.*

Opposite: *Paperback writer David Goodis with Humphrey Bogart and Lauren Bacall, during the filming of* Dark Passage.

Page Six: *Quarter Books illustrated its erotic novels with posed photos featuring appropriately unsavory looking models.*

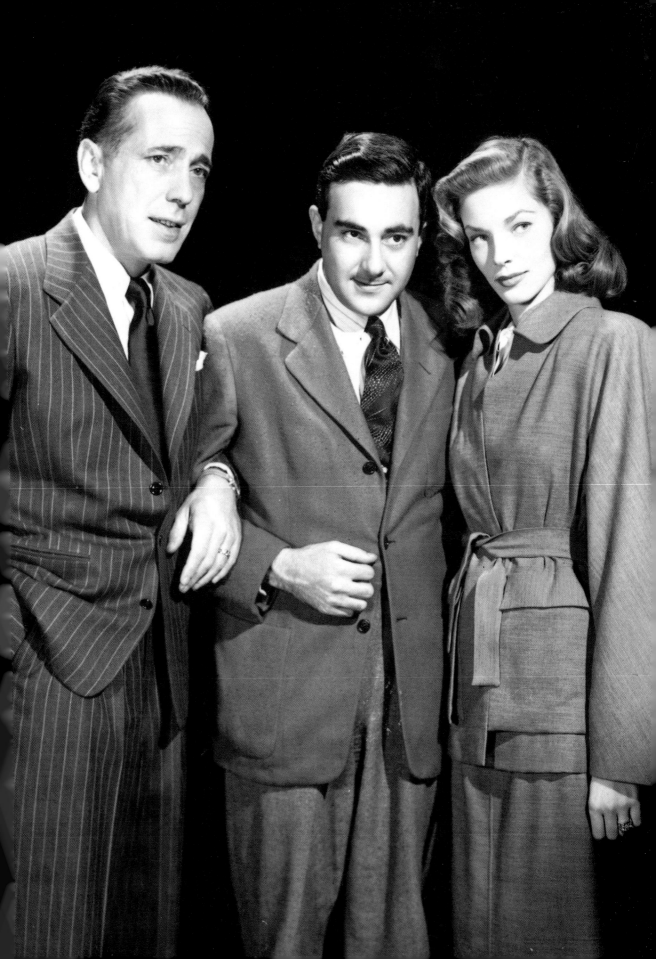

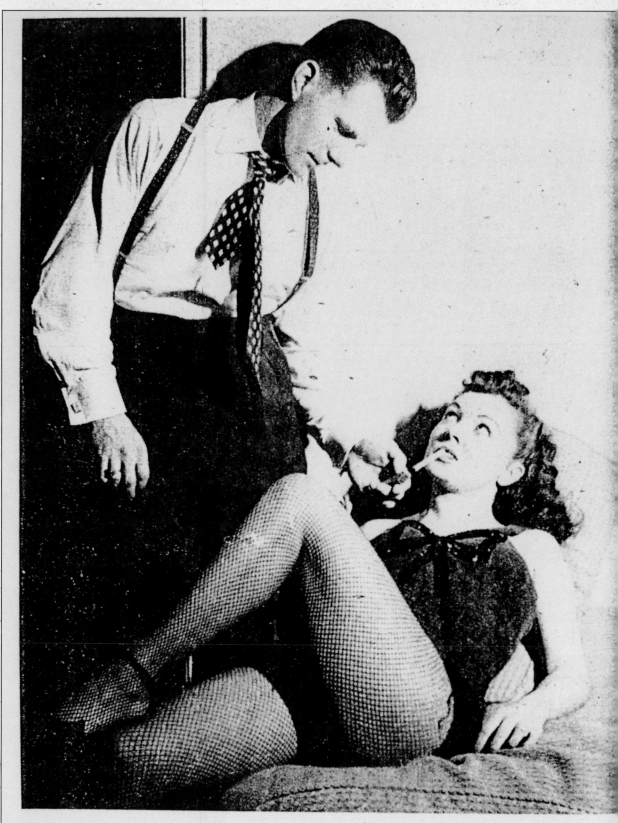

"Okay, kid," Chet told her, "you can cut out the shakes and stop worry-
ing. I got in touch with a few big-wigs and you're completely in the clear."

(Specially posed by professional mode...

Contents

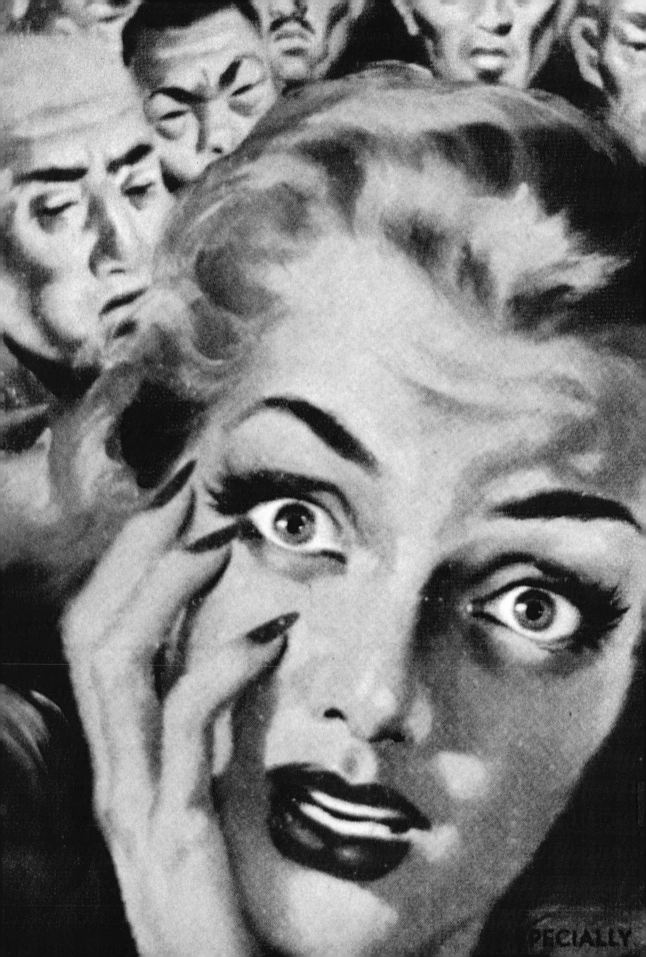

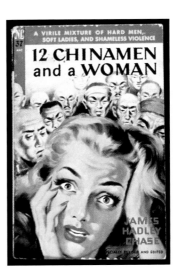

Introduction

Whated we have here are some paperback books, circa 1945-1955, remnants of a brief but gloriously subversive era in the history of American publishing. These cheap, pocket-sized editions came wrapped in lurid cover art and screaming headlines, hyping stories about crime, lust, and violence. Casting a neonlike glow from wire racks in drugstores and bus depots across the nation, they conveyed an alluring collective vision of a corrupt and sensual world.

Above and left: This was the tasteful retitling of a British tough-guy writer's 12 Chinks and a Woman.

his, and they stood there together and over the roofs of the old buildings they watched the sun rise.

THE END

DON'T MISS THIS EXCITING NOVEL

No. 74 "LEG-ART" VIRGIN by GENE HARVEY

25¢ QUARTER BOOKS

THE BEST IN EXOTIC FICTION

Until Jeff David came along, luscious Lisa Hanson had no way of knowing much about life — and love. But Jeff taught her all she needed to know — and with his help, the beautiful blonde soon found herself a famous model. But the path leading to this pinnacle was paved with passion, heartbreak, and disillusionment . . . Here is the thrilling, unexpurgated exposé of the modelling profession — as candidly revealed by the inimitable Gene Harvey. Here is a book that will thrill you from cover to cover! . . . Don't miss this tale of passion!

ON SALE AT YOUR NEWSSTAND!

The paperback industry began in 1938 with a 2,300-copy printing of *The Good Earth*, by Pearl Buck; by the mid 1940s it was growing by leaps and bounds. Dozens of competing imprints had entered the field, many with ties to the rowdy pulp magazine business, few with any experience or interest in the more genteel traditions of the hardcover book trade. Paperbacks began to show a marked increase in hard-sell sensationalism. Packaged with a strictly democratic approach to the contents, they displayed no distinction between marginal mystery writers and titans of literature. Emile Zola or

Above: An advertisement for Leg Art Virgin, *an erotic paperback, published in the larger digest size.*

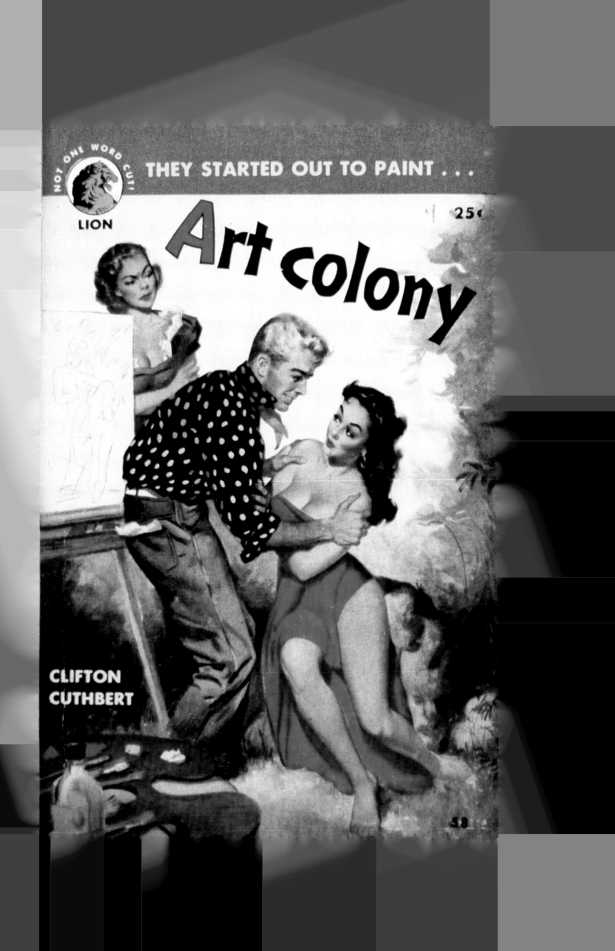

THEY STARTED OUT TO PAINT . . .

25¢

Art colony

CLIFTON
CUTHBERT

58

Sax Rohmer, D. H. Lawrence or Brett Halliday, everybody got the same frenzied blurbs and risqué illustrations, causing academics to tear their hair out—especially when the classic works were abridged by 50 percent and given catchy new, usually salacious, titles.

Softcover publishers were not trying, however to appeal to college professors. The twenty-five-cent editions—one-tenth the price of a hardcover book at the time—were aimed at a working- to middle-class male readership, largely a mass of ex-G.I.s who had picked up a taste for portable fiction while in uniform (thanks to the free Armed Services Editions distributed by the government during the war). The books catered to the former soldiers' supposed preference for sexy, violent stories, plainly written and not too long. The grim, sordid tone of so many postwar paperbacks could also be ascribed to the veterans' tastes—readers who had been trained to kill were understandably inclined to have a darker than average viewpoint.

Far Left: A typical "sleazy digest" from the early 1950s.

Left: The title could describe the contents of any typical postwar paperback.

Opposite: Dell's cut-rate Ten-Cent Books were in a pamphlet format. The experiment lasted less than a year.

At first nearly all paperbacks were reprints, culled from a variety of sources. The publishers then came to realize they could just as easily, and almost as cheaply, commission new works conceived directly for the softcover market. From these paperback "originals" there began to emerge, along

WILLIAM IRISH

A cheap and evil girl
hopped-up killer against a ci

MARIHUA

"A cheap

evil girl se

a hopped-u

killer aga

a city"

POPULAR
LIBRARY

233

Macamba

LILLA VAN SAHER

Their bodies swayed to
the frenzied mating
rhythm of the Tamboe.

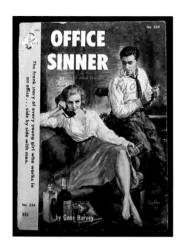

with the steady supply of Westerns and whodunits, distinctive new styles of commercial fiction full of a gritty realism, frankly erotic, lacking in sentiment or conventional morality, and with an iconoclastic eagerness to explore the controversial and the taboo. Whole genres would develop around such shocking subject matter as drug addiction, racism, homosexuality, and juvenile delinquency. Sociopathic heroes, unpunished crimes, and depressive endings were not only allowed in these paperbacks, they were encouraged. This was a long way from the easygoing escapist reading found in the "cheap fiction" of the past.

Above: *A saga of the workplace from Cameo Books.*

Right: *An early, more subtle approach to hard-boiled cover art, from Handi Books.*

Opposite: *Lusty dancing in the tropics, from Popular Library.*

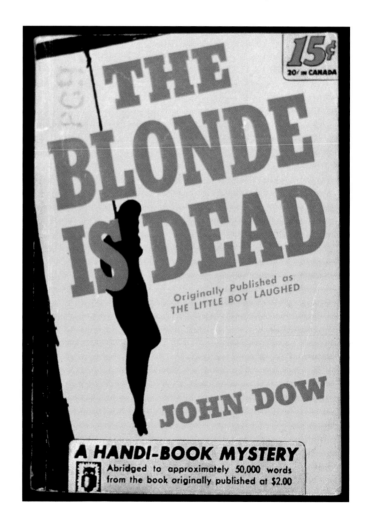

Inevitably, in a place and time as censorious as America in the 1950s, the softcover industry's emphasis on the sensational and the forbidden was bound to get it into trouble. Although millions of U.S. readers were happily being separated from their quarters without complaint, a tiny but strident fragment of the populace was outraged by the

Above: A bop-set original from Lion Books.

Opposite: Commies made popular softcover villains.

Left: A typically lurid extract from a 1950s paperback.

"TURN OUT THE LIGHT!"

I kissed her hard, tasting the musky odor of marijuana that clung to her warm lips.
"I'm scared, Jim," she murmured, her voice soft and Mexican. Her body trembled beneath my hands. "You're safe here," I told her. "The killers don't know where this apartment is."

"They know everything," she said. "They'll give it to me worse than Juan got it."

"Forget about Juan," I said. She stood up and carried the marijuana butt to the fireplace. She came back to the bed slowly. "Turn out the light," she said, slipping out of her dress. Then it was dark.

She whispered. "Make me forget it all!"

PRINTED IN THE UNITED STATES

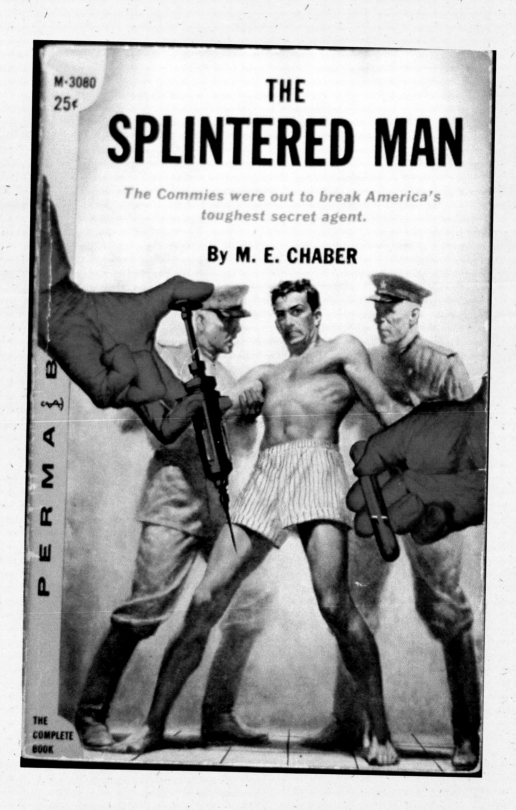

M·3080
25¢

THE
SPLINTERED MAN

The Commies were out to break America's
toughest secret agent.

By M. E. CHABER

PERMA B

THE
COMPLETE
BOOK

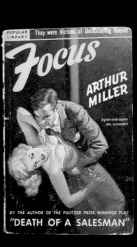

Above and right:
Arthur Miller's
pre-Pulitzer novel
given the lurid
treatment by artist
Rudolph Belarski.

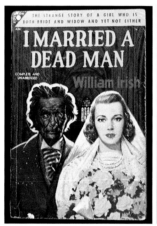 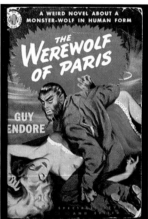 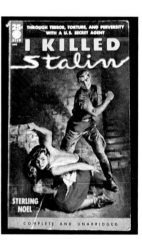

Right: One of the most popular names in the early paperbacks, William Irish was also known as Cornell Woolrich.

Middle right: This Avon cover for Guy Endore's classic was considered shocking in its day.

Far right: A classic sex-and-violence cover with a timely Cold War theme of indubitable authenticity.

common availability of such depraved and dangerous reading matter. Educators, psychologists, religious leaders, and other spoilsports joined to fight this common enemy. The U.S. Congress, identifying a target as publicity-garnering as the Red Menace, agreed to investigate and if necessary destroy the evil scourge known as the paperback book. In the end, with threats of fines and imprisonment looming, an abashed industry tamed its excesses. The American paperback would never be the same.

For this volume I have gathered a sampling from the era of lurid softcover publishing, artifacts now highly prized by collectors and trading for hundreds of times their original cost. But be forewarned—these vintage paperbacks have lost none of their power to bedazzle and corrupt the innocent mind!

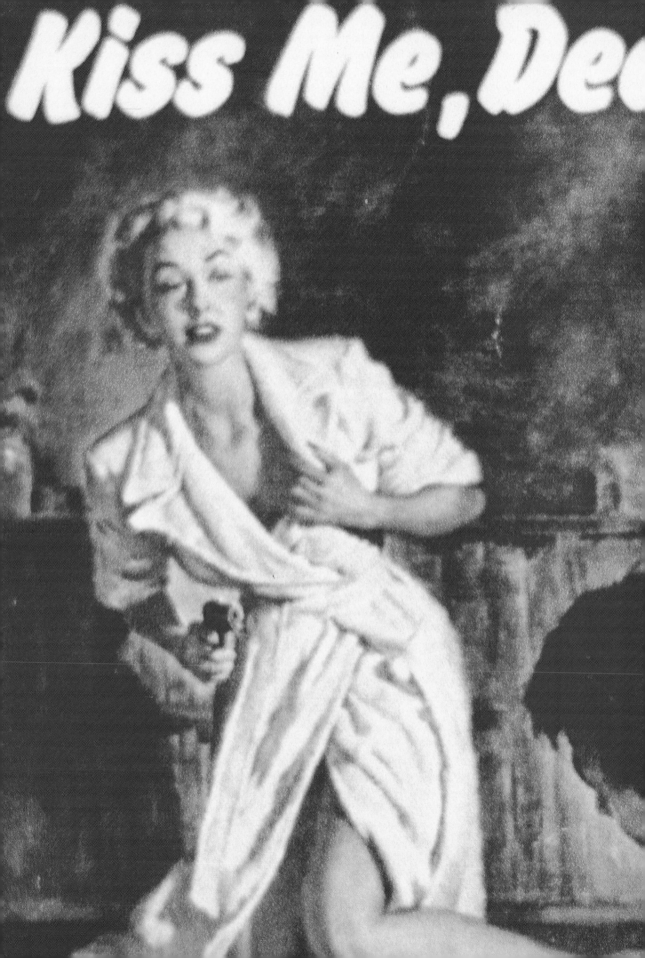

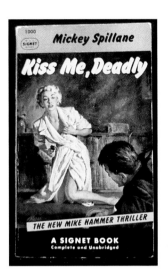

Shot in
the Dark

In the 1950s, Mickey
Spillane was the most popular novelist on the
planet. The Brooklyn-born, Elizabeth, New Jer-
sey–raised author wrote blood-and-sex-drenched
mysteries of an unprecedented ferocity, tales more
often about vengeance than detection, usually
climaxing in cathartic prose poems of murder and
destruction. The public loved him. Alarmed critics

Above and right: After Kiss Me, Deadly, *Spillane
retired from novel writing for the rest of the decade, for
reasons never made clear.*

and pointy-headed intellectuals called him a vulgarian, fascist and illiterate, the architect of the nation's destruction. Spillane, an easygoing Air Force vet, former salesman in Gimbel's basement, and writer for comic books, knew you couldn't please everybody. "My mother loves the stuff," he said at the time. "My father thinks it's crud."

With 150 million or so copies of his books sold, there is no need for us to describe them in detail. There were seven titles published in the postwar decade under discussion: *I, The Jury; My Gun is Quick; Vengeance is Mine; One Lonely Night; The Big Kill; The Long Wait;* and *Kiss Me, Deadly*. Six were about his tough

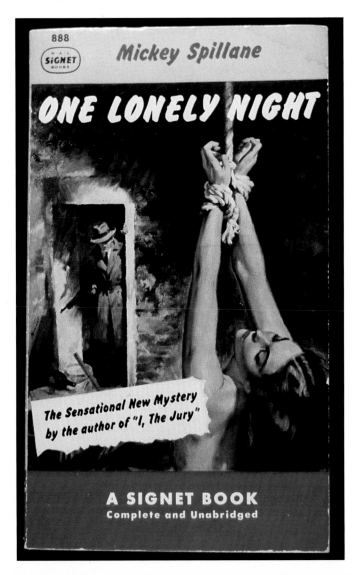

Left: Mickey Spillane was a phenomenal bestseller in paperback.

Opposite: The colorful Mickey Spillane portrayed his own ferocious private eye, Mike Hammer, in the film version of The Girl Hunters. *Actress Shirley Eaton is in the bikini.*

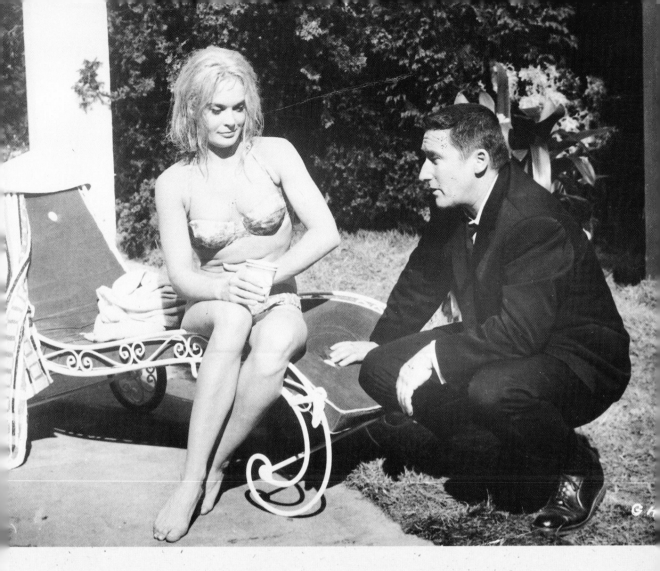

private eye, Mike Hammer; the one out-of-series book, *The Long Wait,* was about a tough amnesiac. Hammer's investigations were always personally motivated, but they happily coincided with a higher calling, a philosophical mission somewhere between those of Ayn Rand and The Shadow:

People. How incredibly stupid they could be sometimes. A trial by law for a killer. A loophole in the phrasing that lets a killer crawl out. But in the end the people have their justice. They get it through guys like me once in a while. They crack down on society and I crack down on them. I shoot them like the mad dogs they are.

Hammer was a soft touch with old army buddies and heart-of-gold hookers in trouble, a barbarous, Old Testament

A DELL BOOK

DELL

330

REPORT FOR A CORPSE

by
Henry
Kane

. . . and on
dames, deaths,
desperados
by peter
chambers

avenger when it came to crooks and communists. Every casual encounter with the bad guys was a ballet of gore and breaking bones. Here, from *The Big Kill*:

. . . I dragged out the .45 and let them look down the hole so they could see where sudden death came from. It was the only kind of talk they knew. . . I snapped the side of the rod across his jaw and laid the flesh open to the bone. He dropped the sap and staggered into the big boy with a scream starting to come up out of his throat only to get it cut off in the middle as I pounded his teeth back into his mouth with the end of the barrel.

The plots were serviceable, although Agatha Christie would have lost no sleep over them. It was the writing that sold the books, Spillane/Hammer's pounding, charismatic, inescapable voice, a hero not afraid to go a little, shall we say, crazy now and then, and the daring, shocking stuff that went on between the plot points—outlandishly vivid violence and forthright erotic details. One infamous passage alone—*"All that was left were the transparent panties. And she was a real blonde."*—probably earned Mickey a small fortune. The endings were much talked about, tying sex and violence together for one last sucker punch, as in these final sentences from *I, The Jury*:

Slowly, a sigh escaped her, making the hemispheres of her breasts quiver. She leaned forward to kiss me, her arms going out to encircle my neck.

The roar of the .45 shook the room. Charlotte staggered back a step. Her eyes were a symphony of incredulity, an

Opposite: One of the many private-eye series to follow in Spillane's footsteps.

Below Left: Postwar paperbacks generally made their appeal to blue collar males.

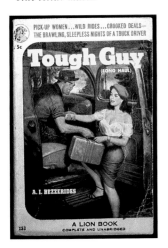

Above Right: In their attempt at idiomatic, hard-boiled terseness, paperback titles were sometimes laughable.

unbelieving witness to truth. Slowly, she looked down at the
ugly swelling in her naked belly where the bullet went in. . .
"How c-could you?" she gasped.
I only had a moment before talking to a corpse, but I got it in.
"It was easy," I said.

Although all of his books would be
published first in hardcover, Spillane's
enormous breakthrough came in paper-
back—his first novel sold just 7,000
copies in the first edition, while the
softcover reprint moved over two million
in two years. To many people Spillane *was*
the postwar paperback, in all its lurid,
two-bit glory; indeed, if he had not come
on the scene when he did in 1948, bring-
ing to the mass market his innovative,
ultravisceral style and a provocative new
direction for the hard-boiled detective
story (and if it had not met with such
enormous success in softcover), the paper-
back era of which we speak might have
developed in an entirely different way.
Spillane's work and the reaction to it
electrified and inspired the softcover book
industry: it defined the paperback reader
for them.

Following closely upon Spillane's first
huge success came a second decisive in-
fluence on the immediate future of the
paperback. Fawcett, publishers of pulps,
comic books, and assorted blue collar
magazines, seeing the success other magazine publishers
such as Dell were having, decided to go into the softcover
book biz. A contract to distribute Signet Books (Spillane's
home) was supposed to prevent that, but a loophole allowed

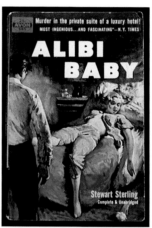

Left: Another typical
tough title and sultry
cover painting.

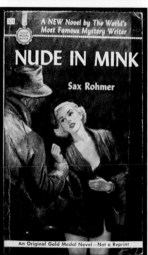

***Below left:** The*
legendary Sax Rohmer
was among the "big
name" authors lured to
write for Fawcett's
Gold Medal line.

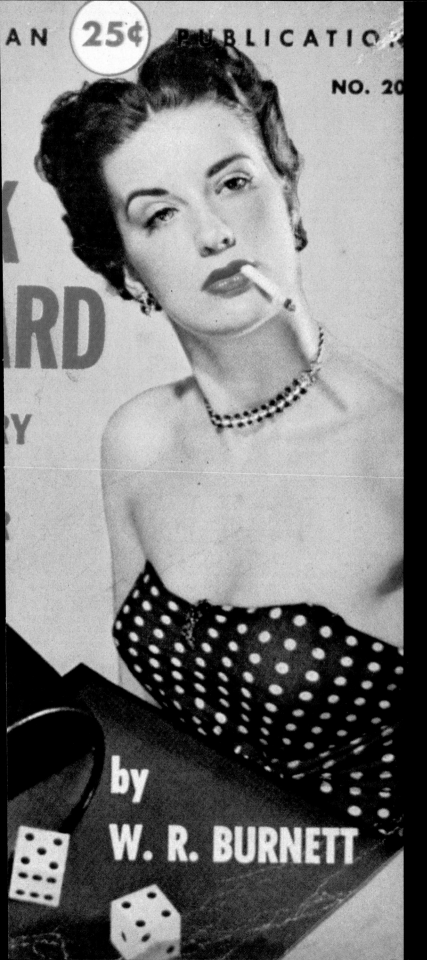

by

W. R. BURNETT

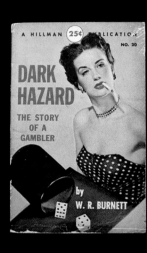

A HILLMAN 25¢ PUBLICATION NO. 20

DARK HAZARD

THE STORY OF A GAMBLER

by W. R. BURNETT

Above and Left:
Reprints of W. R.
Burnett's earlier novels
were a staple in this
period. After 1950 he
also wrote paperback
originals.

*Above: John D.
MacDonald, one of
the first and most
successful writers of
paperback originals.*

Fawcett to put out their own paperbacks if they contained original material. Signet was probably thinking in terms of a joke or puzzle book. Only a couple of small, fringe houses were publishing original fiction in paperback in 1949. No one at the time could conceive of a commercially viable book, or an author with any credentials, going straight to the unreviewed cheap reprint market. No one but Fawcett.

The company's Gold Medal Books, offering substantial advances of two to three thousand dollars, and utilizing the persuasive powers of an *éminence grise* named Bill Lengel, once Theodore Dreiser's editor, managed to lure original manuscripts out of a number of "big name" writers. Among them were W. R. Burnett, author of *Asphalt Jungle* and *Little Caesar*, Sax Rohmer, creator of FuManchu, and best-selling suspense novelist Cornell Woolrich. Burnett's *Stretch Dawson*, Rohmer's *Nude in Mink*, and Woolrich's *Savage Bride* all racked up huge sales for Gold Medal. But in addition to the name brand authors, Gold Medal found new or unestablished novelists— including John D. MacDonald, Louis L'Amour, Day Keene, Charles Williams, Gil Brewer, and future Watergate burglar Howard Hunt—whose books were also highly successful. A good portion of Gold Medal's stable came over from the dying pulps. MacDonald's first novel and Gold Medal's twenty-sixth release, *The Brass Cupcake*, was originally earmarked as a detective pulp novella; it was revised and enlarged for the paperback publisher, thus beginning a relationship that would last the rest of MacDonald's life. The greater length gave him breathing room for what would become his signature ruminations and sociological asides, as in this early passage from *Cupcake* on corruption in postwar Florida:

> *Before the war Florence City was a quiet middleclass resort. But the war expanded the field of endeavor. Gambling houses, breast of guinea hen under glass, seagoing yachts from Havana, seventy-dollar nightclub tabs for a quiet dinner for two— with the appropriate wines, of course. . . A new group had*

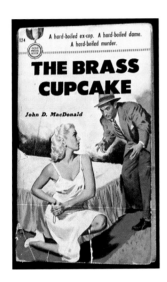

Above: The Brass Cupcake, *originally intended for the pulps, became John D. MacDonald's first published novel.*

*taken over the beaches. Middleaged ladies with puffy faces
and granite eyes brought down whole stables of hundred-
dollar call girls, giggling like a sorority on a welfare trip.
Sleek little men with hand-blocked sport shirts strolled around
and made with the Bogart gestures.*

*Boom town, fun town, money town, rough town. Lay it on
the line. You can't take it with you. Next year comes the H
bomb. Put it on the entertainment account.*

Where Spillane had set a new tone, MacDonald and the other
"Gold Medal Boys" established a whole new species, the
paperback writer. Under the inspired editorship of Richard
Carroll, a former newspaper reporter and Hollywood screen-

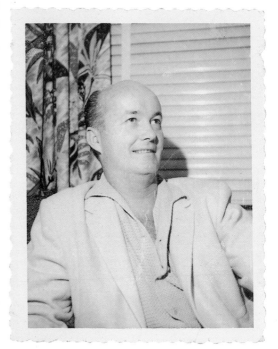

writer, Gold Medal discovered dozens of
good writers and turned out hundreds of
entertaining books. In addition to the
aforementioned regulars, its stable of au-
thors included David Goodis, Wade
Miller, Bruno Fischer, Richard Matheson,
Ann Bannon, Wenzell Brown, and Dan
Cushman. It published the enormously
successful Shell Scott detective series by
Richard Prather, a parodic take on the
Mike Hammer phenomenon, full of jokes
and farcical situations as well as the requi-
site blood, sex, and Commie-bashing.
Peter Rabe, a German-born writer with a
Ph.D. in psychology, did seventeen Gold
Medal originals in this period, most of
them ultratough tales of professional
criminals, written in diamond-hard prose
that bore comparison with Hammett and Paul Cain.

Harry Whittington, often called the "King of the Paper-
backs," wrote softcover originals by the score, for everyone from
Fawcett and Avon, at the top, to Ace, Graphic, Handi,

Above and Left:

One of the compulsively

readable thrillers by

Harry Whittington.

Phantom, Uni, Carnival, and Venus at the middle, bottom, and subbasement. Producing nearly a hundred novels in the 1950s alone, Whittington maintained an amazingly high standard. His best work was generally for Gold Medal—*Brute in Brass*, *Web of Murder*, *Fires That Destroy*—books of seamless prose and clockwork plotting, compulsively readable. And Gold Medal published most of Lionel White's taut, ironic "caper" novels, *The Snatchers*, *The Big Caper*, *Death Takes the Bus*, and others. A former long-time editor of grubby "true detective" magazines, he knew the ambiance of lowlife, small-potatoes criminality like the back of his hand. White's attention to nuts-and-bolts detail led to a dubious tribute, some French crooks using one of his paperbacks as a step-by-step handbook for a real-life kidnapping.

Gold Medal's releases covered a wide range of masculine-interest categories, from Westerns to horror to exotic adventure, as well as such exotic 1950s fiction genres as lesbianism and juvenile delinquency, and profitably revived the so-called "movie novelization," quickie paperbacks written from produced screenplays, timed to the release of the upcoming motion picture. But if it could be said there was a typical or emblematic Gold Medal book it would have to be the small-scale, contemporary suspense story with sex, as provided by Keene, Brewer, Williams, and Whittington, loosely following in the footsteps of James M. Cain and his *Postman*. The ingredients: an ordinary Joe, a slightly out-of-the-ordinary Jane, a dead body, a bitter ending.

For their first seventy-eight titles, Gold Medal racked up an astounding twenty-nine million sales. Far from being shunned as the book industry predicted, original paperback fiction, Fawcett's shot in the dark, was a great and trend-setting success. In due course, most of the established paperback

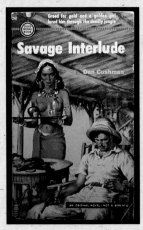

Below left: The harsh cover lines reflected the influence of Mickey Spillane's style of graphic violence.

Above: Dan Cushman specialized in lusty adventures in exotic, tropic ports.

Opposite: Gold Medal was the pioneer in publishing original fiction in paperback.

654

GOLD
MEDAL
BOOK

25¢

Pure Sweet Hell

For a dame like this
I'd sell out to Satan —
but the devil himself
was ahead of me in line

MALCOLM DOUGLAS

publishers, as well as dozens of small and newly opened houses, were all seeking their own original material, the softcover industry suddenly freed from the limiting and expensive need to license everything from sources other than the writers themselves.

The paperback original came into its own just as the pulp

SEVEN SLAYERS

by

PAUL CAIN

Author of "Fast One"

AVON PUBLISHING CO., INC.
119 W. 57th St., New York 19, N. Y.

Published by Arrangement with the Author

Left: The title page for Seven Slayers, *a collection of* Paul Cain *stories first published in* Black Mask *magazine.*

magazines were printing their last. Paperbacks had been taking the place of the pulps on the newsstands for years and now they replaced them as a bottomless market for fiction writers. As was true of the pulps, the softcover business supported a motley and colorful guerrilla army of storytellers, from the extremely gifted to the inept to a few singular, visionary talents. Some saw their job without pretense, a way to make a living, grinding out novels without expectation of fame or big bucks. For others it was a proving ground or a halfway house on the way to more prestigious hardcover sales or more lucrative work in the movies or television. For some others it was the last or near-last stop on a downward spiral from previous literary successes or ambitions. In any case, the mass-market paperback would be the medium for which a number of

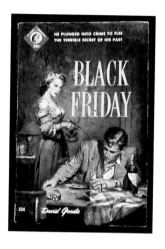

Above: After a taste of Hollywood success, David Goodis retreated to paperback oblivion.

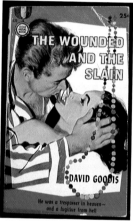

Above right: Though virtually unknown in his own country until recent years, Goodis has been a long-admired master of noir lit. in France.

distinctive and important postwar American writers would create much or all of their greatest work.

Philip K. Dick, now widely considered among the handful of great science fiction writers, spent most of his book-writing career—begining with *Solar Lottery* published by Ace in 1955—lost in the s-f paperback "ghetto," his ambitious, satiric, paranoid masterworks earning him between $1-2000 and having a newsstand shelf-life of half-a-year or less.

Charles Willeford was a career soldier, near the end of his hitch when he locked himself in a San Francisco hotel room and pounded out his first, eccentric, novel, *High Priest of California*, a strange and sleazy tale of a blandly psychotic used car salesman. Royal Giant bought it for a five-hundred dollar advance, publishing it in 1955 inexplicably bound with a Talbot Mundy high adventure novel. Willeford followed this awkward premiere appearance with a series of brilliant, wildly oddball novels—*Pick-up, Honey Gal, The Woman Chaser*—all

sold to obscure, soft-core sex publishers such as Beacon and Newstand Library. Willeford seems to have intended to write Gold Medal–styled sex and crime stories, but his esoteric, Nabokovian sense of humor and odiously solipsistic, generally insane heroes kept getting in the way of sales to better established paperback houses.

Chester Himes was a black American whose early works were painful, enraged, autobiographical novels about race and inequity in the United States. Self-exiled to France and badly in need of money, Himes agreed to write, in English, a series of Harlem-set detective stories for the French paperback publisher Gallimard. The series—including *A Rage in Harlem*, *The Crazy Kill*, *Cotton Comes to Harlem*—was republished in America by Gold Medal and Avon. Writing to be easily and quickly translated into French, Himes told the stories in a fast-paced, cinematic style without introspection or digression. The books were hard, brutal, and viciously funny, with

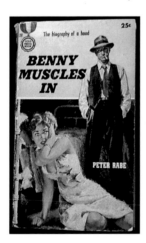
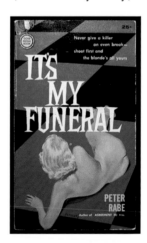

some of the most vivid and exciting action sequences ever written. Working under the imposed limitations of the French *Serie Noir* crime line, Himes was necessarily cut off from the ordeal of explicit sociological truth telling (although the crime stories were full of implicit critiques of America's social realities), enabling him to unleash an enormous talent within an escapist form. Unlike many of the writers for whom

Far left: At his best, Gold Medal regular Peter Rabe was a worthy successor to Hammett.

Left: Tough-guy writer Rabe had a Ph.D. in psychology.

Opposite: Cain's novel was technically a softcover original, though it was actually a ten-year-old, unsold magazine serial.

JAMES M. CAIN

The ROOT of his EVIL

"They call me a tramp because I made a sucker of a millionaire"

"Make love to me!"

At the sound of Myrna De Spain's passion-loaded voice, Flagg's big frame made a slow half circle. What he saw made the detective gasp. The girl stood before him in a sheer black nightgown. Long legs, round white thighs, sloping hips, magnificent breasts—all that he had guessed at was revealed before his eyes. But she also had a gun.

"I want you to make love to me, Flagg," she said again. He smiled. "That's a service I give only to my clients," he said. She raised the gun. "If you don't," she said, "I'll kill you." Flagg shrugged his wide shoulders and moved toward her. It was a wacky case, anyhow.

Left: Romance, hardboiled style, from a vintage paperback mystery.

Below: A mainstay of New Jersey–based Graphic Books, Saber also wrote under his real name, Milton Ozaki.

softcover assignments were a dead end career-wise, Himes achieved international recognition and a degree of financial security from his paperback books, and a street near his final residence in Spain was named in his honor.

David Goodis, paperbackdom's bard of Skid Row, poet laureate of the American Failure Story, was a former pulp writer who hit it big for a few years in the late 1940s when his novel *Dark Passage* became a Humphrey Bogart vehicle and the author went to work at Warner Brothers in Hollywood. An enigmatic personality to say the least, Goodis drifted away

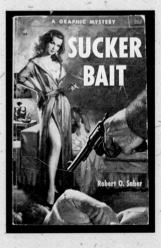

from the big time and a promising future, returned to live at his parents' house in Philadelphia, and began grinding out paperback originals for Gold Medal and Lion Books. His quirky crime and sex novels like *Street of No Return*, *The Moon in the Gutter*, and *Down There* (filmed by Truffaut as *Shoot the Piano Player*) were tawdry, voluptuously depressed recreations of his own psychological state and self-imposed retreat into

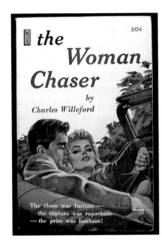

oblivion. The titles and cover lines (on *Down There*: "From the great concert halls of the world—he descended the stairway to hell") of Goodis' paperbacks would have worked just as well in his author's bio. Goodis was a lost and exhausted soul when he died in 1967 at age forty-nine.

Jim Thompson, recipient of much critical attention in recent years, had been trying to keep a writing career off the ground for two decades and had about kissed off his ambitions when he landed an assignment from Lion Books, one of the many houses in the early '50s trying to emulate the Gold Medal formula. Thompson's first softcover original, *The Killer Inside Me*, was a bone-chilling, unforgettable tale told by a bumpkin Sheriff—Lou Ford—who is in fact a sadistic psychopath and murderer. The chatty, first-person narrative voice gives the book its sickening impact:

That was my main reason for killing Elmer, but it wasn't

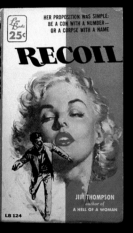

RECO

25¢

HER PROPOSITION WAS SIMPLE:
BE A CON WITH A NUMBER —
OR A CORPSE WITH A NAME

RECOIL

JIM THOMPSON
author of
A HELL OF A WOMAN

LB 124

JIM

A HELL

124

Above and right:

Now considered one of

the masters of the crime

novel, Thompson had

not one of his thirty

books still in print

when he died in 1977.

the only one. The Conways were part of the circle, the town, that ringed me in; the smug ones, the hypocrites, the holier-than-thou guys—all the stinkers I had to face day in and day out. I had to grin and smile and be pleasant to them; and maybe there are people like that everwhere, but when you can't get away from them, when they keep pushing themselves at

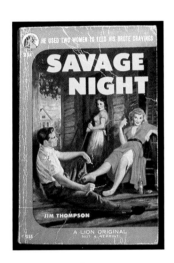

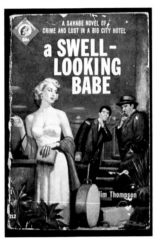

you, and you can't get away, never, never, get away. . .

Well.

Thompson followed this tour de force with nearly two dozen more paperback novels, most of them dark, nihilistic nightmares with horrid, insane protagonists. Thompson often seemed to be out to prove what a paperback writer could get away with when no one was looking, and had a fondness—in books such as *Savage Night*, *Hell of a Woman*, and *The Getaway*—for bizarre endings, the plots suddenly turning inside-out and eating themselves alive before the appalled reader's very eyes. *Savage Night*'s narrator—a diminutive hit man—describes his own ghastly death, a Jim Cain–derived gimmick taken to a grotesque extreme. Literally falling to pieces (chopped up by an axe-wielding female) Charlie Bigger concludes:

Above: One of Jim Thompson's Lion originals, Savage Night *is about a midget hit man.*

Far right: Thompson wrote a dozen novels for Lion Books, editions now highly prized by collectors.

I circled the room twice before I found it, and there was hardly any of me then but it was enough. I crawled up over the pile of bottles, and went crashing down the other side.

And he was there, of course.

Death was there.

Chapter XXVIII

And he smelled good.

Love Life of a

HOLLYWOOD
MISTRESS

SHE WAS YOUNG, BEAUTIFUL
AND WILLING

By *Florence Stonebraker*

Author of RENO TRAMP

AN ILLUSTRATED BOOK

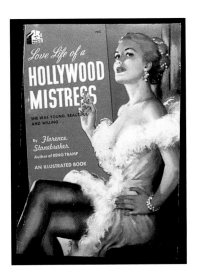

Love for Sale

Sex was the not-so-secret weapon that paperbacks could wield over every other medium of mass entertainment in the postwar period. Neither radio nor television could even hint at things erotic, and while movies could address more mature subject matter and were certainly capable of a visual sensuousness, the Hollywood cinema remained a determinedly chaste art form. Paperback publishers had the relative freedom that the law granted to literature and none of the re-

Above and left: Quarter Books included posed photographic illustrations in many of its sexy digests.

straints of good taste that hampered the hardcover houses.

Not, mind you, that it took much provocation to raise the temperature of a severely repressed or sheltered citizenry. *God's Little Acre*, an "earthy" tale of the rural South written in 1932 by Erskine Caldwell, who was something like the poor man's William Faulkner, sold six million copies when it was revived for a paperback edition, and largely on the basis of around three titillating paragraphs about a passionate peasant named Darling Jill.

Caldwell's success spawned the first of the many quirky, forgotten subgenres created by the early paperbacks—this a series of Southern regional novels about assorted dirt farmers and undereducated nymphomaniacs: *Cracker Girl, Bayou Girl, Spawn of the Bayou, Shanty Girl, Shanty Town Tease, Backwoods Girl, Backwoods Hussy, Backwoods Shack, Backwoods Bride, White Trash, Swamp Hoyden, Hoyden of the Mountains, Hill Hoyden, Hill Hellion* and *Hillbilly in High Heels*, among others. While the fad lasted, the corps of "hillbilly fiction" specialists included, besides Caldwell, Charles Williams, Harry Whittington, Whit Harrison (Harry Whittington), Hallam Whitney (Harry Whittington), and John Faulkner, younger brother of the Nobel Prize winner (come to think of it, he was the poor man's Faulkner).

Paperbacks emphasized sex appeal wherever possible, of course, and most houses released a percentage of books with explicitly sexual themes, but there were also a number of smaller outfits that issued nothing but erotic fiction. Even the lowly, reviled paperback industry had to have something to look down on, and this view was ably provided by the sex book publishers. These fringe houses, such as Venus Books, Quarter Books, Cameo, Croydon, and Ecstasy Novels, produced titles of such delirious sleaziness that even crusty, hard-bitten cigar store owners must have wept with embarrassment at the prospect of selling such monumental trash.

Below left: The popularity of Erskine Caldwell's novels of a lusty rural South inspired hundreds of meretricious imitations.

Below: Joining the Caldwell imitators was William Faulkner's younger brother John, with a series of sexy rural South paperback originals.

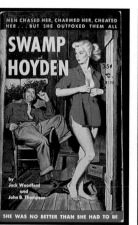

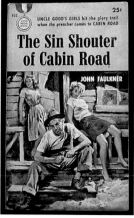

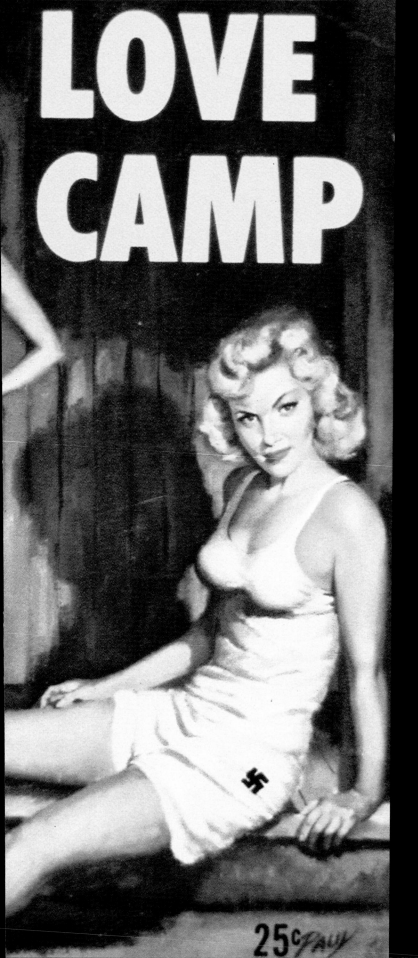

LOVE CAMP

25¢

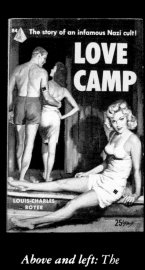

B4 — The story of an infamous Nazi cult!

LOVE CAMP

LOUIS-CHARLES ROYER

25¢

Above and left: The blunt appeal of some lurid-era paperbacks was often as amusing as it was sordid.

VENUS BOOKS

163

A Nurse's Uniform Did Not Protect Her from Herself!

Private Nurse

A NEW, EXCITING NOVEL

by David Charlson

Author of NIGHT NURSE

35¢

The books were packaged to move, flashing their wares like an open-raincoated exhibitionist—voluptuous cover art, sweat-soaked blurbs, and titles that had no time for the niceties of evocation or double entendre: *The Virgin and the Barfly, Keyhole Peeper, Vera is a Tramp, Divorce Racket Girls, Cheap Hotel, Red-Light Babe, "Leg Art" Virgin, Love for Sale, Confessions of a Chinatown Moll, Sins of a Private Secretary, Television Tramp, Indiscretions of a TV Sinner, Affairs of a Ward Nurse, Loves of a Girl Wrestler,* and so on. Venturing beyond the gaudy wrappers was invariably a letdown, the vast majority of these erotic novels surely as unreadable then as they are today. Plots were deficient excuses for a series of sleazily teasing encounters between man and woman. Actual sexual intercourse could be described only obliquely, coy euphemisms and strained metaphors the lingua franca of '50's erotica hacks. Here, an emetic consummation from *Hitch-Hike Hussy:*

Top right: No doubt beating out many worthy contenders, this Beacon release was an award winner.

Bottom right: Doctors and nurses were the frequent subjects of provocative paperback exposés.

Opposite: Another medical worker with a shocking private life.

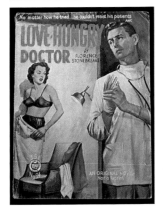

> *Breath scattered through his lungs with all the frenetic irregularity of a bevy of frightened quail erupting from tall grass, and when his mouth met her soft lips, there was nothing of the sweet affection that had characterized their first touch. With a sinuous twist, the girl sat up on a level with him and the stunning entry of her tongue turned his will to water.*
>
> *Her hands were about his neck and his face grimaced for a moment in a twitter of fear that she'd hurt herself. . . His flesh tingled, as if some accomplished voluptuary were skating with razor-edged blades across the surface of his senses.*
>
> *With a sudden exhibition of power, he lifted her away from*

the confining area of the steering wheel and over to the back seat, following her on his stomach; there he reverted to the age of mud and stones, falling into a serpentine atavism with ease whenever the primordial urge demanded.

The best—if that is the word I'm looking for—and longest-lasting of the houses of sleaze was Beacon Books. The line was lively, occasionally well-written, and displayed a charming sense of the absurd in the deadpan way it bannered its own prestigious-sounding *"Beacon First"* Award of Excellence to select releases, like *Confessions of a Psychiatrist* ("*Every Boudoir Was His Office: Every Patient His Plaything—*"). God only knows to whom Beacon would have given a Nobel. It released some truly unusual titles, including *Paprika,* a novel of passionate gypsies by the accursed director of the silent film classic *Greed,* Erich von Stroheim, and several extremely eccentric, jet-black-humored works by Charles Willeford, including *Pick-Up* ("*He holed up with a helpless lush. A story that builds to a shattering climax!*") and his hilarious early masterpiece, *Honey Gal.* Among the publisher's regular contributors were the prolific Jack Woodford (otherwise known for a series of eminently practical guides to writing fiction) and Orrie Hitt, author of well over a hundred erotic paperback novels in this period, most of them for Beacon. Residing in a small town in upstate New York, Hitt had a grinding regimen, twelve-hour days in front of an aged Remington Royal perched on the kitchen table, surrounded by iced coffee, noisy children, and Winston cigarettes, pausing only for supper or to watch wrestling or Sergeant Bilko on the television. Hitt produced a novel every two weeks, for

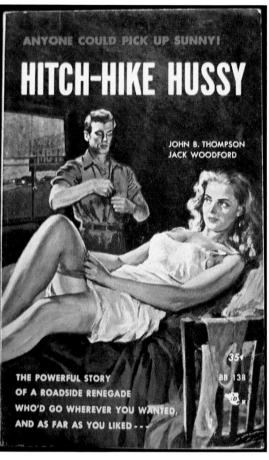

Above: Jack Woodford specialized in risqué fiction and his byline was a constant on early 1950s paperback racks.

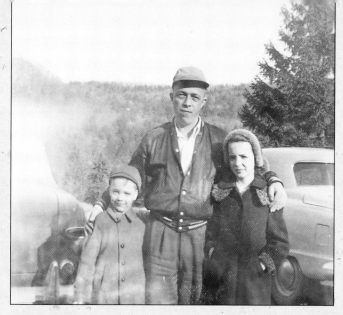

Right: Orrie Hitt, seen here with children Peg and David, was an unsung master of sordid '50s erotica.

which he was paid as little as $250. Occasionally he would have to leave home to research a new background, such as the nudist colony he visited for the Beacon book *Nudist Camp* (*"They Worshipped Nature in the Raw"*), although he reportedly did not disrobe. Even a sex-book writer had to maintain a certain journalistic objectivity. Hitt's lively body of work included such neglected classics as *Dolls and Dues* (*"The Sordid Story of a Union Boss and His Women—Timely as Tomorrow"*), *Trailer Tramp* (incidentally, another *First Award* winner),

Right: Career soldier Charles Willeford wrote his brilliant black comedies for a series of sleazy, low-paying paperback houses.

HER LOVE WAS **HOT**...**PEPPER HOT!**

PAPRIKA

B157
35¢
K

BY ERIC VON
STROHEIM

**NO MAN COULD RESIST THE SHAMELESS
GYPSY TROLLOP—*NO MAN WANTED TO!***

Opposite: Erich von Stroheim, Hollywood's favorite Hun, was at a low point in his career when he penned this lusty story of gypsy life.

Ellie's Shack *("They Were Always Peeking and Pawing at Her. How Could a Girl Stay Good?")*, and Girls' Dormitory *("A Scathing Attack on the Evils of Off-Campus Housing—And Co-Eds Obliged to Live in Dangerous Proximity!")*. They mapped a sordid universe of "heels" and "tramps," characters with all the incandescent glamor of a fifteen-watt bulb.

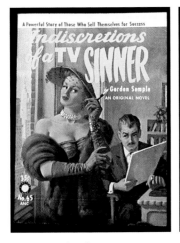

Above: What better way to fight the competition than to reveal—in complete detail—the shameful private lives of television personnel.

Above right: The keyhole graphic was a popular cover motif in this period.

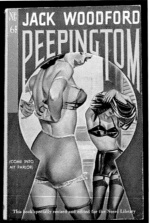

The first paperback reputed to have broken the sales records for *God's Little Acre* was one similarly noted for its sexual candor, a Gold Medal original titled *Spring Fire*. The book was a multimillion-copy seller, and like the Caldwell book it launched its own distinct subgenre. *Spring Fire* was erotic fiction with a new twist for the mass market: a relatively sincere, realistic account of a lesbian relationship. Gold Medal had already touched on the subject in the more discursive *Women's Barracks* by Tereska Torres, one of the company's first major successes, but *Spring Fire* would become a trend setter.

It told the story of two Cranston University sorority sisters, naive, earnest Mitch, and Leda, worldly queen of the campus. Leda, a freewheeling bisexual, seduces the vulnerable Mitch, who promptly falls in love with her. But Leda will have none of that, concerned with her high-profile status in the college community. She explains to Mitch the shallow facts of campus life:

"You better get to know men too, kid. I mean that. There are a lot of people who love both and no one gives a damn, and they just say you're oversexed and they don't care. But they start getting interested when you stick to one sex. Like you've been doing, Mitch. I couldn't love you if you were a lesbian."

"I'm not," Mitch said, wondering what the word meant.

"I'm not. I-I just haven't met a man yet who makes me feel the way you do."

"Maybe you don't give them a chance," Leda answered.

But in the end it is Leda who can't cope, her desperate attempt to save her reputation driving her literally crazy, leaving her confined to a "nut house" and her Tri Epsilon sisters wondering "if insane people can read mail."

The author was Vin Packer, a pseudonym for a young woman writer named Marijane Meaker. Discussing the book's genesis, she recalled for me:

The editor in charge at Gold Medal was Dick Carroll, a colorful Irishman who'd come East from Hollywood with a history of screenwriting and drinking. We were having a drink at the Algonquin one night and talking about a fey little story I had done for the Ladies' Home Journal *about*

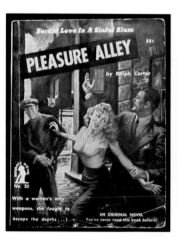 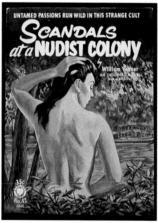

boarding school girls. Dick asked if there was any homosexuality at the school and I said, "Sure, and a lot more of it at my sorority in college." And he said, "We're starting this paperback original line, why don't you write a book about that." The only restriction he gave me was that it couldn't have a happy ending and he suggested it end with

Far left: Intimate was one of many of "exotic" — i.e. erotic — paperback publishers in the 1950s.

Left: Sex-digest titles were blunt and to the point, never risking subtleties like double entendre.

Opposite: Orrie Hitt was the author of dozens of erotic novels for Beacon Books, among other sex-book publishers.

Shabby Street

by Orrie Hitt

IDC K

B 104

An Original Novel—
not a Reprint

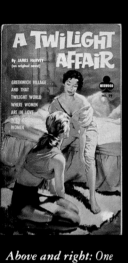

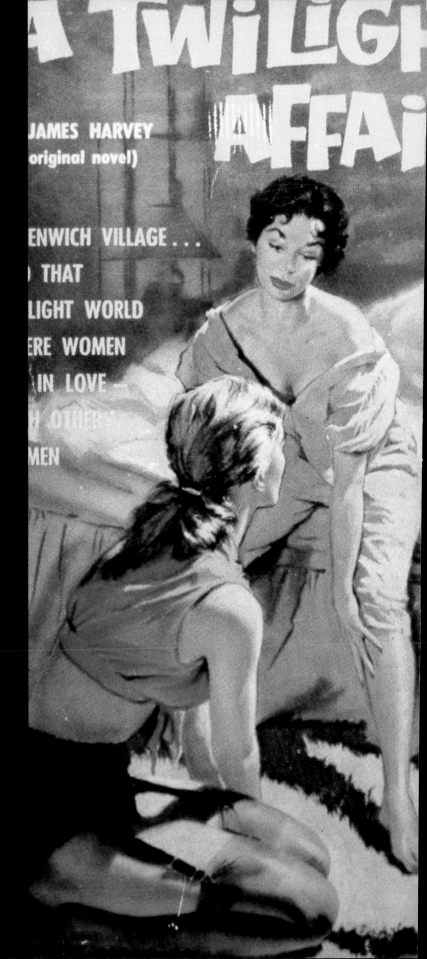

Above and right: One of the numerous works of "lesbiana" following in the best-selling wake of Spring Fire.

the lesbian going crazy. Otherwise the Post Office might seize the books as obscene.

I think Dick Carroll figured the story would have prurient appeal to men, but when it came out I got just hundreds of letters, boxes of them, all from women, gay women. It took them all by surprise, this big audience out there.

Top right: Ann Aldrich, like Vin Packer, was a pseudonym for Marijane Meaker, who specialized in crime and lesbian fiction for Gold Medal.

Bottom right: The Gold Medal original Women's Barracks, *touching on lesbianism in the armed forces, was a top seller throughout the 1950s.*

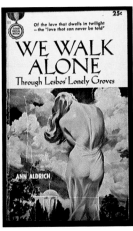

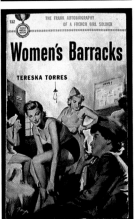

Meaker, who began writing crime novels under her Vin Packer pen name, followed *Spring Fire* with a series of lesbian-themed books and a new byline, Ann Aldrich ("Dick said to pick something all-American sounding, like 'Henry Aldrich' the kid on the radio show," Meaker recalls) and these too were very successful for Gold Medal. Various other publishers began releasing lesbian paperbacks, over a hundred of them in just a few years time—such titles as *Olivia* ("*The Story of a Love That Dared Not Tell Its Name*"), *The Damned One* ("*What Made Her Act Like a Man?*") and *This Bed We Made* ("*She Loved Her Husband—And Her Girl Friend!*"). (There were, incidentally, a smattering of paperbacks exploiting the subject of male homosexuality, but these were not nearly as successful, lacking, perhaps, a certain crossover appeal). While few lesbian novels went the route of *Spring Fire*, with its heroine turning psychotic, most of the books were downbeat, even tragic in their depiction of what the copywriters repeatedly called "a twilight world." Still, for all their undoubted appeal to the "prurient interests of men," many lesbian paperbacks contained sufficient psychological truths or documentary detail of gay life in the 1950s to be found worthy of study and critical applause by feminists rediscovering these books decades later.

52 A HUMPHREY CAMPBELL MYSTERY
NO HANDS ON THE CLOCK
GEOFFREY HOMES

A BANTAM BOOK
COMPLETE AND UNABRIDGED

Cover Story

There is no more distinguishing characteristic of the postwar paperback than its favored style of cover illustration: garish oils on canvas, a dreamlike, exaggerated realism, the depicted scene an overheated, pheromone-charged moment from the enclosed narrative. With their typically lurid hues and tawdry views of modern urban life, the covers looked like freeze-frames from some lost Cinecolor B-movie.

Reflecting the most frequent subject matter of the paperback novel in this era, the illustrations

Above and left: Another subtle, graphic approach to a hard-boiled mystery.

offered endless variations on recurring motifs, namely crimson-lipped females in lingerie, granite-jawed tough guys, blazing .45s, rumpled bedsheets, neon-lit hotel rooms, a blue-gray haze of cigarette smoke, alleyways and street corners at permanent midnight.

These sensationalized, pulp magazine–influenced covers have been referred to—understandably but erroneously—as representing the primitive stage in the history of the mass-market paperback. In fact, they embody the paperback's rambunctious adolescence. The earliest softcover releases, from Pocket Books, were illustrated in a more restrained, bourgeois style, basically interchangeable with the demure dust jackets of hardcover books. The closest thing to a sensational Pocket Books cover was the illustration for the 1941 edition of Zola's *Nana*, featuring the title character onstage in a presumably sheer white costume.

During the war years, among the major new softcover

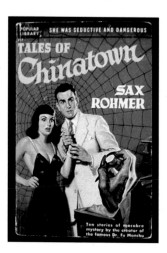 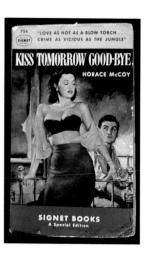

houses such as Dell and Popular Library and even smaller presses like Handi, the preferred style of cover art was "sophisticated," using poster and commercial art techniques of abstraction and symbolism. The illustration, for instance, on the cover of an early Popular Library mystery, *Fog*, could easily pass for an elegant travel poster (absent, of course, the giant

Far left: One more brighter-than-life artwork by the prolific Belarski.

Left: James Avati's dark and moody style of realistic painting made him the most respected cover artist of his day. Most of his work was for serious literary titles, although he did the occasional hard-boiled novel as well.

Opposite: A typical use of poster art techniques in the war-years paperback cover.

FOG

VALENTINE WILLIAMS
DOROTHY RICE SIMS

crabbed hand). Dell had a preference for wispy airbrushed images on its covers, sometimes strikingly evocative, other times just wispy. Dell's most memorable design innovation was not on the front but on the back covers. The so-called "mapbacks" were just that—the entire back covers given over to maps, or variously charts, blueprints, or what have you to represent story locale or scene of the crime: a stretch of California highway, the interior of an apartment, a sheik's "city of stones." It was an enjoyable if slightly goofy gimmick and, amazingly, managed to last nearly ten years. Mapback editions—there are hundreds—are collected by many old-paperback enthusiasts.

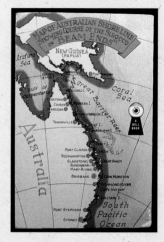

Left, above, and opposite: Examples of Dell "mapbacks," the back cover given over entirely to a map or other depiction of a book's setting.

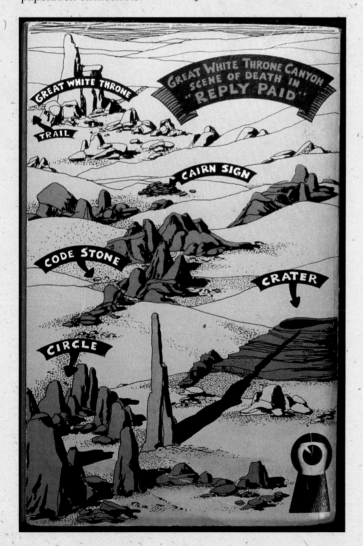

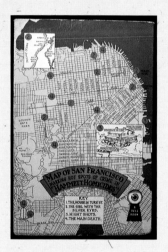

The most strikingly creative of the nonrealistic illustrators was Robert Jonas, a conscientious artist with ties to the abstract-expressionist movement. Much of his work for Penguin (U.S.) and Signet made brilliant use of symbols in collages that were like aesthetic rebus puzzles. Jonas not only read the books he was illustrating, he pondered their intellectual or metaphoric significance. Obviously, in the lurid onslaught about to hit paperback publishing, Jonas was going to feel a little displaced.

The trend toward realism in cover illustration—primarily the voluptuous realism of the pulps—began after the war and was all but ubiquitous by the end of the decade. Gone were those cosmopolitan graphic designs. Now came the vivid portrayals of sex, violence, action. Compare Pocket's 1947 art

A. Merritt

CREEP, SHADOW CREEP

for Zola's *Nana*, for example, to its once "shocking" 1941-edition cover; depicting the same scene, the postwar cover art had a bluntly erotic style, a more vivacious, nuder Nana making direct, seductive eye contact with her potential readers.

The new style had the gut-level appeal of a tabloid flashgun photo, with headlines to match. Blame it on the growing competition for quarters, new reader demographics, and the phenomenal sales of Mickey Spillane, it had at least as much to do with the sudden availability of certain artists, masters of the pulp-realist form. The pulps were dying in the late forties,

Opposite: Avon Books pioneered pulpy realistic paperback covers, though its earliest ones were primitive and probably appeared old fashioned even at the time of release.

Right: The typical cover illustrations in the paperback's lurid era were direct, emotional, and sexy.

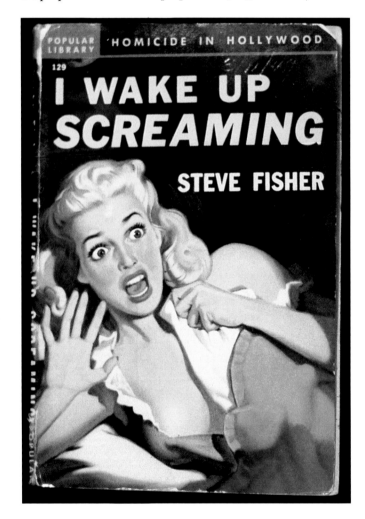

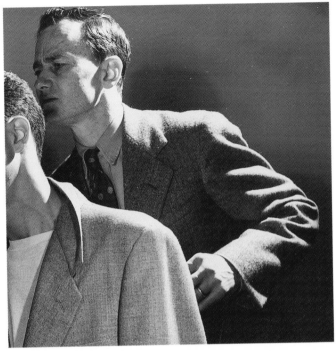

and the great veteran pulp illustrators such as Rudolph Belarski, Earle Bergey, Norman Saunders, and Rafael de Soto, all having twenty-plus years experience in painting resplendent, hyper-real pulp covers, moved over to the thriving paperbacks.

The new covers, with their dazzling color schemes and cinematic vivacity, their female figures out of some Herculean wet dream, were irresistible. As graduates of the pulp assembly line, the newly arrived softcover illustrators had no trouble in turning out as many as three or four finished paintings in a week, allowing their "school" to become all the more visible and influential. For a time, Belarski's work seemed to adorn every one of Popular Library's hundreds of releases. Popular paid him $250 per cover. Belarski had ambivalent feelings about the company's ever-increasing demands for arousing art. "It didn't matter to them if it wasn't in the story," he told historian Piet Schreuders. "The editors would say, 'Don't worry, we'll *write* it in! Just make sure to *make 'em round!* They were too damn sexy. . . ." Added to Belarski's tremendous

Left: James Avati, the Rembrandt of paperback illustrators, preparing to paint the cover for Black Boy *by Richard Wright.*

Opposite: The Pocket Books cover art from the early 1940s resembled the demure illustrations for hardcover jackets.

THE GENERAL
DIED AT DAWN

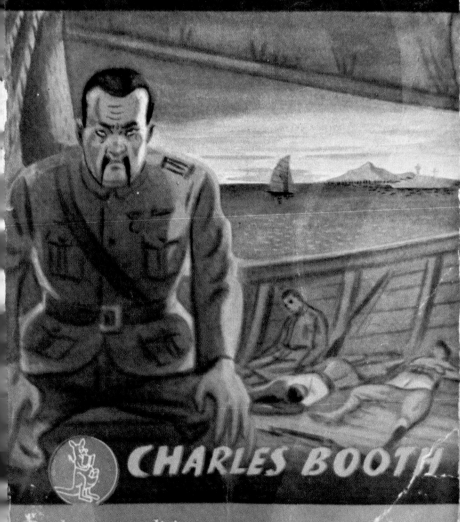

CHARLES BOOTH

Pocket BOOK edition COMPLETE AND UNABRIDGED

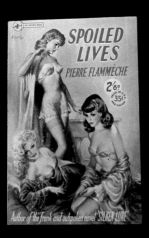

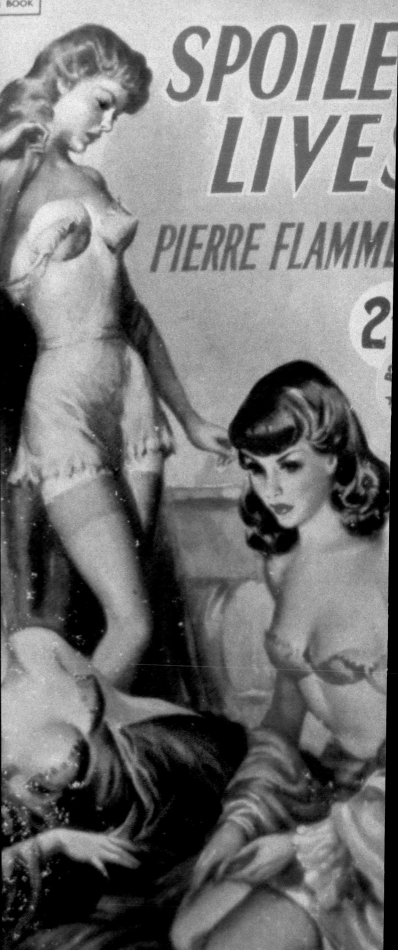

output was the work of countless Belarski imitators, all trying to approximate his fever-pitched images.

There were, however, other schools of realistic painting besides the one derived from the pulps. No discussion of paperback cover art could fail to mention the name of James Avati, the Rembrandt of illustrators. Beginning in 1948, working almost exclusively for Signet Books with its line of

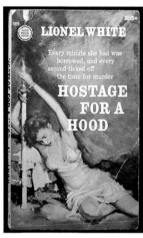
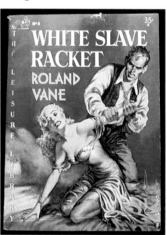

exploitable literary titles, Avati produced covers in a dark, moody, richly textured style. His characters and settings, the flesh tones and subdued browns of his palette, were living, breathing things. "Avati found a perfect style for those covers," says Stanley Meltzoff, an Avati friend and admirer as well as a first-rate illustrator in his own right. "He was a great painter of what had been called American Scene or Social Realism or the 'Ashcan School' of painting as developed in the 1930s, and it fit perfectly the novels New American Library published, mostly from the 1930s, by Caldwell, Farrell, McCoy and so on."

Aside from his great skill, one reason Avati's paintings looked so much more *real*, so *lived-in*, was that he worked not in New York but in the small New Jersey town of Red Bank, in a studio on the corner of Main Street and Broad Street, and hired nonprofessional models. "Red Bank was a small, degenerating American town then, slowly going broke," says

Right: Sex and violence sold these vintage paperbacks, preferably in combination.

Far right and opposite: A recent enthusiasm among collectors of paperback cover art, R. Heade was a British artist whose plush, erotic paintings adorned assorted sensationalist U.K. paperbacks, many repackaged for U.S. distribution.

Meltzoff. "And downtown Red Bank was Everywhere USA, but the flip side of Norman Rockwell. Avati used the local people there as his models, and so they didn't look like professional models, didn't pose or dress like models. Instead, what they did was represent their own lives, posing in a rather clumsy and embarrassed way, which made them look very true." Avati's influence was substantial, with many disciples among the newer illustrators and art directors seeking to repeat his effects. Eventually, like most vogues, this one cooled, and Avati, the innocent originator, was made to do something else. "Art directors," Meltzoff explains, "demanded he paint more attractive, stylish women—in other words, real models—and they started to demand magaziney vignettes, and that subtracted everything that was of value to Avati. It broke his heart. The art directors didn't know what they had."

By the mid 1950s, the realistic style of cover painting was being filtered away. It was replaced with a "lighter touch," supposedly more modern than the "old-fashioned" and "heavy" oil works of Avati or the pure pulp style of Belarski and imitators. In addition, the governmental investigations into "pornographic materials" by the Gathings Committee in Washington made the paperback industry largely shy away from its more extreme behavior, those covers with the leering faces, bosomy babes, and bleeding corpses. The cover artists of the

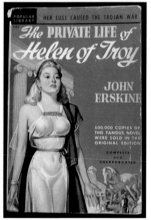

postwar period either changed their styles or faded from the scene. In either case, by the mid 1950s their variously mesmeric, haunting, and outrageous art was fast becoming a thing of the past.

Left: One of the striking cover designs by Robert Jonas, before the onslaught of realistic art.

Below left: The notorious "nipple cover" by Rudolph Belarski. Popular Library urged the artist to make his paintings as sexy as the law allowed.

Opposite: Early on, Dell, like most of the major softcover publishers, used nonrealistic art for its covers.

A DELL BOOK

DELL

223

HAMMETT
HOMICIDES

DASHIELL HAMMETT

WITH CRIME MAP ON BACK COVER

A DELL MYSTERY

BEAT

Raw, penetrating stories,
poems and social criticis
by JACK KEROUAC
NORMAN MAILER

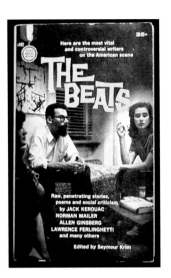

Paperback
Beat

The history of the
Beats and the history of the American paperback
intersect in a chance encounter at an insane
asylum. In the late forties, Allen Ginsberg, Jack
Kerouac, and William Burroughs were the nucleus
of a free-floating group consisting of Columbia
University literary aspirants, remittance men,

Above and opposite: Following the success of On the
Road *and the attention given to Kerouac, Ginsberg,
and friends, paperbacks jumped on the Beat bandwagon
with assorted fiction and nonfiction books that featured
iconoclastic pontifications and bebop slang.*

and Times Square petty criminals. One spring day in 1949, the newly graduated Ginsberg went for an innocent ride with some burglar friends in a car full of stolen dresses; the car crashed and the occupants were arrested. Ginsberg tried flying a novel alibi that merited a newspaper headline ("BOY JOINS GANG TO GET 'REALISM' FOR STORY"), but it didn't work, and the young poet had to plead insanity to stay out of jail. He was sent to the State Psychiatric Institute. There he met a young inmate undergoing shock treatments, Carl Solomon, a high-strung screwup and devotee of Antonin Artaud. Solomon had evidenced his embrace of Dadaism by staging strange, mildly violent events involving peanut butter sandwiches in the cafeteria at Brooklyn College. The treatment the shrinks bestowed on Solomon for his "*crime gratuité*" would provoke convulsions and amnesia. "Fifty more shocks," Ginsberg would write in *Howl for Carl Solomon*, "will never return your soul to your body again from its pilgrimage to a cross in the void."

Allen and Carl, fellow "repentant mystics," became pals in the madhouse, the poet taking inspired notes on Solomon's self-described "raving self-justification, crypto-bohemian boasting, effeminate prancing and esoteric euphemisms plagiarized from Kierkegaard," many of these to be weaved into Ginsberg's most famous work.

Flashing forward to 1952, Carl Solomon, returned to society, was working for his uncle and trying to lead a normal life. His uncle was publisher A.A. Wyn, founder of the Ace line of pulp magazines in the 1930s and just entering the lucrative paperback racket. Getting a late start in a very competitive field, Ace Books was launched with a gimmicky line offering thirty-five-cent "Double Novel Books"—two complete works pressed back to back and wrapped with not one but two gaudy front covers. When you got to the last page of one story you hit the upside down last page of the other; you flipped the book over and began anew. The first pairing was of hard-boiled fare—*The Grinning Gismo* and *Too Hot For*

Opposite: In the 1950s, novelist Paul Bowles, like William Burroughs, a resident of Tangier, Morocco, became a somewhat reluctant charter member of the Beat movement.

840

SiGNET
BOOKS

Strange Romance in the Exotic Desert

THE sheltering sky

Paul Bowles

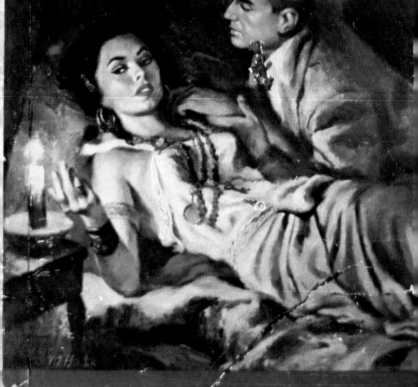

A SIGNET BOOK
Complete and Unabridged

Hell—followed by conjoined Westerns—*Bad Man's Return* and *Bloody Hoofs*. Carl the nephew was given an acquiring editor's position and expected to find more of the same sorts of action-packed fiction.

Meanwhile, Allen Ginsberg had taken on the job of amateur literary agent for his peripatetic friends, starting with Kerouac and Burroughs. Jack had given him a manuscript written on a roll of uncut teletype paper—called *On the Road*. Bill Burroughs, cooling his heels in Mexico after having killed his wife during an infamous "William Tell act" at a cocktail party, had sent Ginsberg—in epistolary fragments—an autobiographical narrative of his days and nights as a heroin addict. Ginsberg took the two manuscripts to everyone he knew in the New York book world. A Doubleday editor, Jason Epstein, told him the drug addict memoir would be worth publishing if it had been written by Winston Churchill. Just then, Ginsberg learned that his insane buddy Carl Solomon was now employed by a paperback house on West Forty-Seventh Street, and the poet/agent made a beeline for the Ace offices. Excited by his friend's enthusiasm, and perhaps genuinely sensing the talent in the messy manuscripts, Solomon made modest three-figure offers for both books, despite what Ginsberg describes as Carl's "nervousness at being thought mentally ill by his uncle."

In fact, Burroughs' first published novel was a perfect paperback original. Compared to the hallucinatory visions and scabrous humor in his later work, *Junkie* was relatively conventional, a nihilistic, cryptically funny but lucidly straightforward hard-boiled tale of criminal low life. Published in 1953 as half of an Ace Double—"69d," in Ginsberg's phrase—with *Narcotic Agent*, "Gripping True Adventures of a T-Man's War Against the Dope Menace," the Burroughs side sported a magnificently lurid cover painting of a man wrestling a packet of heroin from the hand of a sumptuous blonde. A pseudonymous byline (William Lee) was for the sake of his parents' good name. *Junkie* is seldom out of print these days,

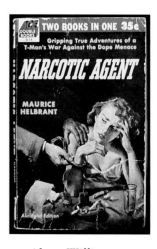

Above: William Burroughs' tale of unregenerate drug addiction and criminal lowlifery was published as an Ace "double," bound with the autobiography of a narc.

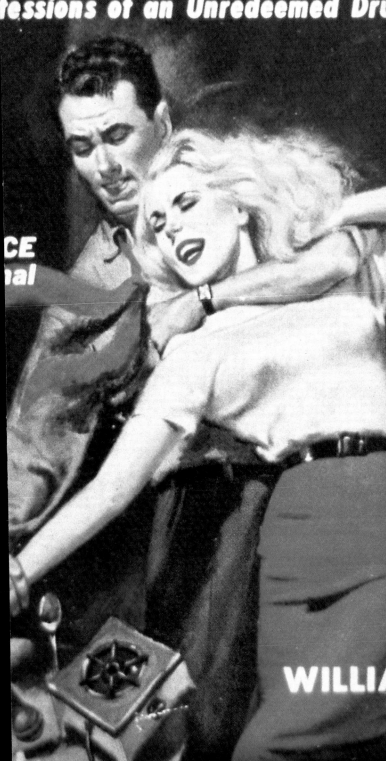

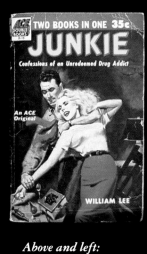

Above and left:
Visionary writer
William Burroughs'
first novel was
published by Ace
Books, with a
magnificently lurid
cover painting.

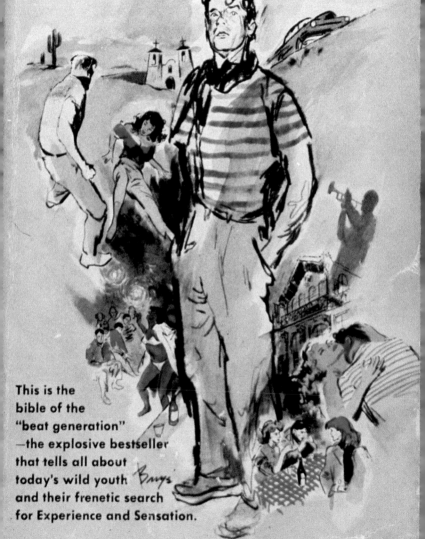

D1619

SIGNET
50¢
BOOKS

JACK KEROUAC

ON THE ROAD

This is the
bible of the
"beat generation"
—the explosive bestseller
that tells all about
today's wild youth
and their frenetic search
for Experience and Sensation.

A SIGNET BOOK • Complete and Unabridged

so let us quote instead from Carl Solomon's exculpatory Publisher's Note on the first page of that rare first edition:

There has never been a criminal confession better calculated to discourage imitation by thrill-hungry teen-agers. . . . William Lee is an unrepentant, unredeemed drug addict. His own words tell that he is a fugitive from the law; that he had been diagnosed as schizophrenic, paranoid; that he is totally without moral values. . . . We realized that here was a document which could forearm the public more effectively than anything yet printed about the drug menace. . . .

For the protection of the reader, we have inserted occasional parenthetical notes to indicate where the author clearly departs from accepted medical fact or makes other unsubstantiated statements in an effort to justify his actions.

On the Road, the Kerouac manuscript Carl Solomon bought for Ace, was more problematic. Solomon asked Jack for substantial rewrites, and meetings between editor and author turned rancorous. Solomon told Kerouac his writing bespoke "repressed homosexuality." Kerouac called Solomon an incompetent lunatic and threatened to break his glasses.

While Kerouac was bitterly revising his opus, agent Allen Ginsberg was making grand plans to turn Ace Books ever more away from double-header Westerns and into a house organ for his unconventional friends and literary heroes—Alan Ansen, Neal Cassady, and Jean Genet among them. But Ginsberg's subversive dream was not to be—the various pressures on editor Solomon's head proved too great for him. He landed in Bellevue Hospital after having been found running through traffic on Eighth Avenue, screaming and throwing his suitcase and shoes at passing vehicles. "I can't get anything done at Ace till he calms down," Ginsberg told his informal clients. "Gad."

It was just as well that Ace gave up on Kerouac. *Junkie* went unnoticed on release, treated no better or worse than any other

lurid drugstore paperback. A considerably different version of *On the Road* came out in 1957, in respectable hardcover and to immediate acclaim and outrage, to a media firestorm, with Kerouac proclaimed the prophet of nonconformity, avatar of the antiestablishment. Every editorial page, every deep-dish journal, every scandal sheet and T.V. talk show found hot copy in the antics and pronouncements of Kerouac and his Beat buddies. In no time every literary figure in America, no matter how congenitally square, was spouting hep phrases and claims of marijuana abuse, lending credence to the notion that the Beats—in reality a tiny circle of unique talents—were indeed a "movement."

Paperbacks would jump on the Beat bandwagon with assorted spurious originals, using the eminently exploitable aspects of Beatdom to full sensationalist advantage: *Beat Ball*, *Like Crazy Man*, *Sintime Beatniks*, *Beat, Beat, Beat* (a collection of hipster cartoons), and *Jesus Was a Beatnik* among them. Gold Medal turned out a more contemplative tome on the subject, *The Beats*, a collection of essays edited by Seymour Krim. Along with the swaggering silliness of the ersatz Beatniks (Herbert Gold, pg. 154: "In New Orleans a pretty little department store model approaches a man at a party, takes off her sweater, then her bra, and says, 'Let's try a new far-out sound on the hi-fi. . .'"), GM hedged its nonconformity by including the grumpy exhortation of a Norman Podhoretz:

. . . the Beat Generation's worship of primitivism and spontaneity is more than a cover for hostility to intelligence. . . This is the revolt of the spiritually underprivileged and the crippled of soul — young men who can't think straight and hate anyone who can; young men who can't get outside the morass of self. . . ."

Pertinent to these pages, Kerouac's success had a tangentially legitimizing effect on the softcover industry. Although a bestseller in hardback, the Signet paperback of *On the Road* was the ideal edition for a bohemian bible, cheap, informal, and portable, ready for tossing into the rucksacks of several

Opposite: From left, novelist Paul Bowles, poet Gregory Corso, and Beat author William Burroughs in Tangier, Morocco. Photo © by Allen Ginsberg.

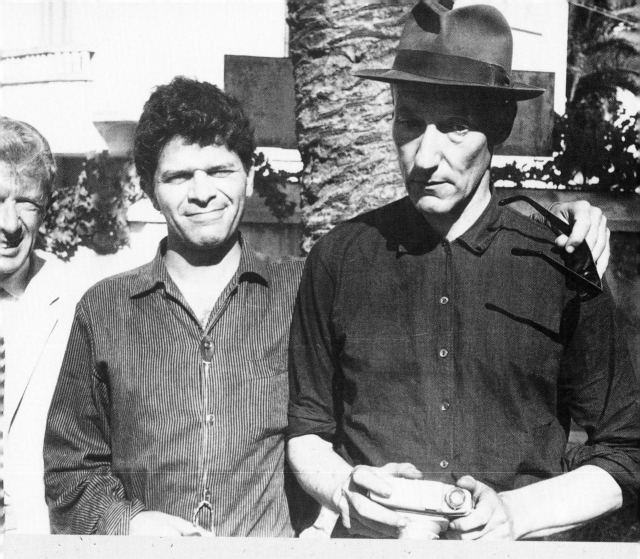

million want-to-be beatniks. In fact, Kerouac followed *On the Road* with several works published as paperback originals, including, for Avon, *Maggie Cassidy* and the underrated *Tristessa*, the tale of a drug-addicted Mexican prostitute. Having a modish author going direct to softcovers was unheard of and confounded the publishing trade's assumption of paperback inferiority and anonymity.

Acclaim for William Burroughs awaited the publication of his second work, and this too was a softcover original, from an exotic and eccentric paperback house called Olympia Press. The Paris-based enterprise of the princely Maurice Girodias, with editorial offices above the tango palace he owned and where he tangoed the nights away, Olympia published ostensibly erotic fiction, written in English, and uniformly wrapped in plain green covers, for the pleasure of British and American

tourists who could not find or would not dream of looking for such material back home. To write these books, with their preassigned titles like *White Thighs* and *Roman Orgy*, Girodias hired from a pool of expatriate layabouts and struggling artists, including Terry Southern and Mason Hoffenberg (whose jointly penned *Candy* was an Olympia hit), Alexander Trocchi, and Iris Owens. The pay was low—"I don't recall the fee involved," Southern once told me, "but it was hardly enough to get us laid"—but so were expenses for those enjoying Left Bank bohemia. Buried among the aphrodisiacal fluff, Girodias also published highly literary works (though generally containing sexual or other controversial material) by Samuel Beckett, Henry Miller, Vladimir Nabokov, and others. Olympia brought out Nabokov's *Lolita* after every American publisher had turned it down in fear.

Left: Here, in the uniform plain green wrappers, is one of the original Olympia Press paperbacks. In addition to Candy *and assorted "dirty books,"* Olympia was first to publish Lolita, The Ginger Man, *and* Naked Lunch.

Opposite: Despite his fame and successful publication in hardcover, Jack Kerouac—or his agent—allowed several of his books to be sold as paperback originals.

Allen Ginsberg, now residing at the "Beat Hotel" on Rue Git-le-Coeur, brought Girodias the manuscript for Burroughs' second work, written in Tangier. To the publisher it appeared to be a chaotic heap of fragments ("It was such a mess, that manuscript," Girodias remembered, "The pages were all eaten away by rats!") and he turned it down. But when an excerpt published in a literary magazine in America caused the magazine to be suppressed for obscenity by the U.S. Post Office, Girodias decided this was the book for him after all.

A Beat cabal gathered in Burroughs' fleabag hotel room, attempting to organize the sprawling masterpiece, but ended up sending sections to the printer in virtually random order. The twelve-franc Olympia Press paperback edition of *Naked Lunch*, published in 1959, caused a stir around the world. Demand for U.S. publication of the Burroughs book and a handful of other startling, renegade works would, by the early 1960s, bring about a revolutionary victory against literary censorship in America.

JACK KEROUAC

A new and hauntingly different novel about a morphine-racked prostitute

TRiSTESSA

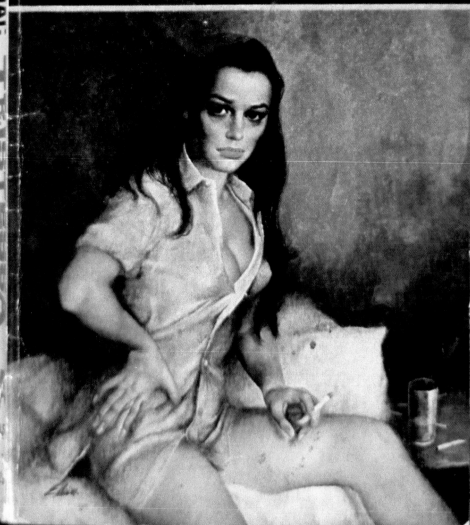

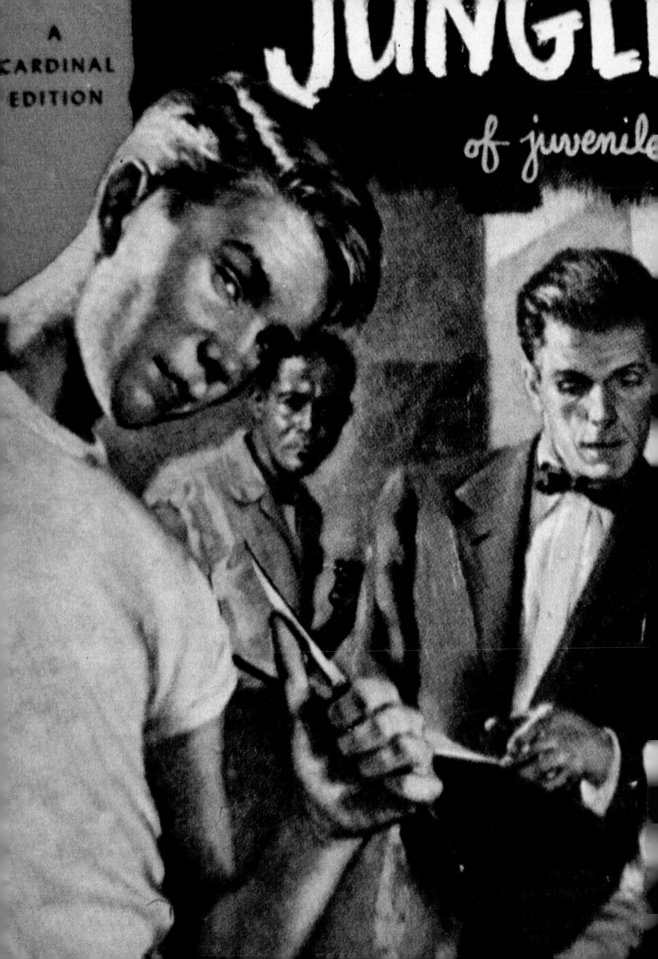

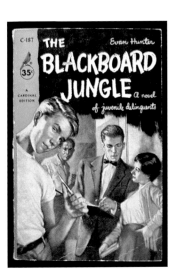

1,000,000 Delinquents

The antics of America's youth provided the postwar paperback with its liveliest and scariest subgenre. These fictional teens, sneering sociopaths outfitted in blue jeans, leather jackets, and pompadours, armed with sproinging switchblades and deadly homemade zip guns, swarmed like disagreeable Mongols across the softcover landscape of the 1950s.

In the course of a single decade, juvenile delinquent lit amassed some three-hundred-

Above and left: Evan Hunter's best-selling novel was told from the perspective of a teacher in a ghetto high school.

plus titles: *D for Delinquent, Play It Cool, Out for Kicks, Juvenile Jungle, Teen-Age Mobster, Teen-Age Mafia, High School Confidential, Jailbait, Jailbait Street, Jailbait Jungle, The Thrill Kids, The Jungle Kids, Boy Gang, Sex Gang, Gutter Gang, Cellar Club, Reefer Club, Cellar Club Girl, Gutter Girl, Reform School Girl, Reefer Girl, Marijuana Girl, Girls Out of Hell, Teen Temptress, Zip-Gun Angels* (females were equal opportunity offenders in

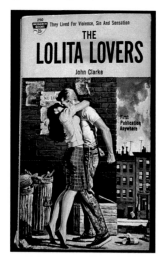

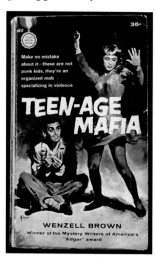

Far left: Not a sequel to the Nabokov masterpiece, just one more sensational saga of young punks and their girlfriends.

Left: Later jd paperbacks had little of the early books' concerns with social realism.

Opposite: Some jd paperbacks included serious prefaces by psychiatrists and sociologists, setting the context for the sensationalism to follow.

paperback delinquency), *Rumble, Rumble on the Docks, Rumble at the Housing Project, Halfway to Hell, The Fires of Youth, Dungaree Sin, The Black Leather Barbarians, The Little Caesars,* and *1,000,000 Delinquents*, to name a small sampling of the jd corpus, nearly all paperback originals.

The books were typically set in an ultra-real urban jungle of rotting poverty and constant brutal violence, a self-contained—in fact, abandoned—world where decay, fear, anger, hopelessness, rape, and sudden death were to be accepted as the norm. Juvenile delinquent fiction was a devastating indictment of American society, but this seemed to go over the heads of most fans of the stuff, captivated instead by the books' damned exciting depictions of gang rumbles, sex orgies, dope smoking, hot rodding, and hubcap stealing. In the beginning, many jd paperbacks even contained introductions by notable shrinks and sociologists, commenting on the

JAILBAIT

WILLIAM BERNARD

Complete and Unabridged

educational value of a given book and our need to better understand these little criminals.

The book that put jds on the literary map was *The Amboy Dukes,* by Irving Shulman, a novel of "wayward youth" in the Brooklyn slums. In addition to its gripping, action-packed narrative, Shulman's book contained a precise detailing of the characters' narcissistic devotion to style, from pastel zoot suits and razor-sharp signet rings to "vaselined hair" shining in reflected light, lending gang life an enticing fetishistic glamor.

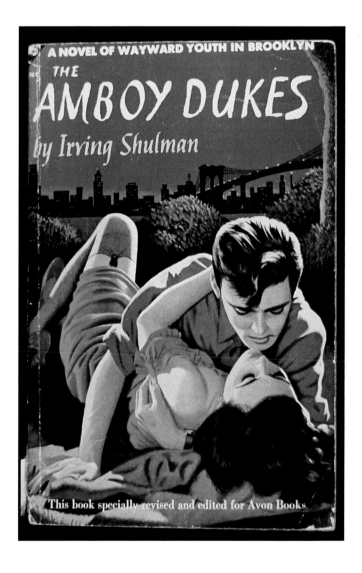

Left: The Amboy Dukes *was the first of the epochal juvenile delinquency novels that would swell newsstands in the 1950s.*

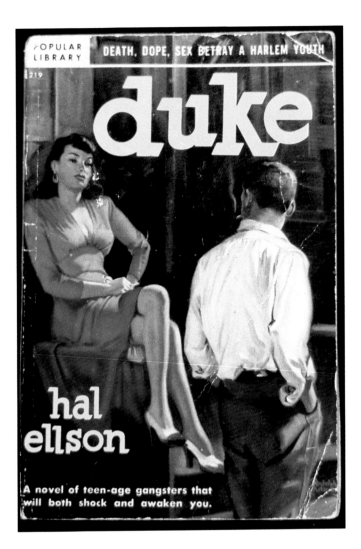

Right: Duke *was the first of many novels by Hal Ellson, the king of juvenile delinquency specialists.*

Shulman was followed into print by a writer with an even more idiosyncratic approach to the subject of urban youth. Hal Ellson's *Duke* was about a black Harlem gang leader, who according to the back cover of the bestselling Popular Library edition of 1949, "ran his gang of teen age hoodlums with fists, feet and a gun. His operations included rape, murder, pimping and smuggling dope. He made his own law. And his code was the savage code of the slum-jungle that was the only home he knew. . . . If you are squeamish, or if you prefer to ignore a dangerous social condition which even now is almost out of

control, this novel is not for you."

The paperback included an innovative glossary of gang terminology, so that nondelinquent readers could be hep to the meanings of "Weed," "Bomber," "H," "Stingy-brim," "Juice man," "Digging the cat," and a few dozen other terms not yet recognized by *Webster's*. Unlike Shulman's more conventional third-person narration, Ellson told *Duke* in the idiomatic, semiliterate voice of his main character, giving the book a blunt immediacy:

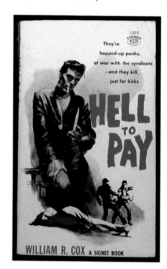

Left: Many jd authors had firsthand experience with the subject, but many more were simply writing what sold.

Opposite: Stories about youthful drug addicts composed a subgenre within the juvenile delinquent category.

We was getting wild by the time Frenchy got back. . . . Everybody piled in that car but before I did I heaved a bottle through a window. Then we drove off looking for strange gals.

When we got back to the neighborhood everybody is high as hell. There's big news. Soon as we drew up to the curb boys who didn't come with us crowded around. The Skibos came through, they said. They raided and stomped hell out of a couple of our boys and ran.

That got me wild. I told my cats to get their artillery. I sent Frenchy back with the car and I went for my pistol. . . when I got back to the corner my boys are waiting for me. There was a real mob.

"The mighty Counts is ready," Chink said. "Do we rumble tonight or don't we?"

"Yeah, man!" I said. "Tonight we rumble!"

Ellson followed *Duke* with *Tomboy*, about a young Manhattan girl gang member. The Bantam paperback had one of those pompous introductions, this one by the dreaded Dr. Fredric Wertham, the era's notorious decency vigilante, and a scolding blurb from the *Christian Science Monitor*: "Some

H IS FOR HEROIN

David Hulburd

MEET THE TEEN-AGE ADDICT

On this strange journey into the fantastic world of juvenile "junkies," you will meet:

ROSA—the trailer camp girl who got her first "fix" from her addict husband on their wedding night.

DAVE—the rich boy who started "blasting just for kicks" and got caught in the narcotics trap.

JOANNE—the Times Square girl who took a "hot shot" and was taken for a ride.

And other teen-age addicts driven to every degradation to keep "the monkey off their backs."

"**If you're the parent of a teen-ager, or if you have a child about to enter that phase of life, you should read this book.**"
Arkansas GAZETTE

readers may feel that the author could have presented his case more persuasively by replacing some of the sensationalism with constructive scenes, but Mr. Ellson seems deliberately to have avoided this method." And amen for that, said millions of satisfied readers.

After *Tomboy* came *The Golden Spike*, a devastating portrait of a young heroin addict, and twelve more novels of New York delinquents—in all, fifteen raw-nerved street sagas that made Ellson the incontrovertible king of jd fiction. His books were noted for their absolute authenticity, and with good cause. Throughout his novel-writing career Ellson was employed as a recreational therapist at a Manhattan city hospital, working with violent or otherwise troubled youths from the meanest streets of New York.

"It was a time when the New York neighborhoods were filled with these teenage gangs, terrific hostility between them, lots of violence, killings," Hal Ellson recalled for me when I tracked

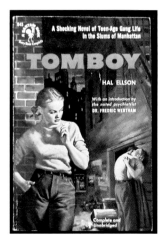

Right: Ellson's second work detailed the grim, violent life of a girl gang member on the streets of New York.

Opposite: The back cover for Monkey on My Back*, a dramatic survey of young junkies.*

him down in Brooklyn. "I saw all kinds of mixed up and crazy things at that job, and I took my notebook everywhere I went. I made lots of notes and a lot of the stuff in my books was just writing down what these young people said.

"I was very close with the gang kids, I was like a father confessor and they would tell me everything. They knew I could be trusted not to repeat anything to the cops. And after *Duke* came out they'd be lined up waiting to talk to me, kids accused of a couple murders, saying, 'Want to hear a good story?' I got all kinds of shocking stuff from these kids. I had earned their respect, they believed in me, and I never gave them away. If they were in serious trouble I would try to steer them to a psychiatrist I trusted, but I never gave them away."

Ellson wrote his novels in long-hand, traveling to and from work on the subway. "I wrote twelve hundred words a

day, six hundred on the way to the job, and six hundred on the way home."

In the 1950s, galvanized by the huge success of the Shulman and Ellson titles, as well as the release of such provocative films as *The Wild One, Blackboard Jungle* (from frequent paperback writer Evan Hunter's best-seller), and *Rebel Without a Cause* (from a Shulman screen story), tales of juvenile delinquency sprang from every paperback house in the country. The demand for product was so great that some publishers reprinted older works like Edward Anderson's Depression-era novel, *Thieves Like Us*, and gussied them up to look like timely J.D. trash. With the rise of rock 'n' roll culture in the late '50s, juvenile delinquent paperbacks expanded their horizons beyond the urban ghettoes to cover the suburban middle class teen scene. Despite their more privileged circumstances, bourgeois American teenagers obviously enjoyed sex, drugs, and law-breaking just as much as their deprived metropolitan cousins. As the genre kicked into sensationalist high gear in this period, those officious prefaces by medical and sociological experts were no longer included—anyway, it would have been difficult to find a respectable psychiatrist to introduce a book with a title like *Lolita Lovers* or one containing passages like this romantic encounter from Edward De Roo's *The Little Ceaesars*:

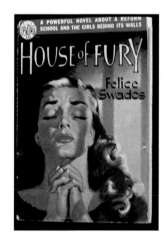

Left: An early account of female jds, also published as Reform School Girl (*one of the highest valued of all vintage paperbacks*).

In front of the juke, a group of tight-pants, sweater-stretching debs were accompanying the loud, guitar-sauced rock. Franny came along and joined Rick in the booth. . .

"I suppose you think you're too good for me?" She reached across and touched his neck, ear lobe and the sensitive spot under his chin. ". . . I'm sick of a guy who makes his bam drop her pants in a sink closet just to fill the treasury for

THE
LITT
CAES

EDWARD De

Above and left:
Violent youth gangs
were a growing social
problem in postwar
America.

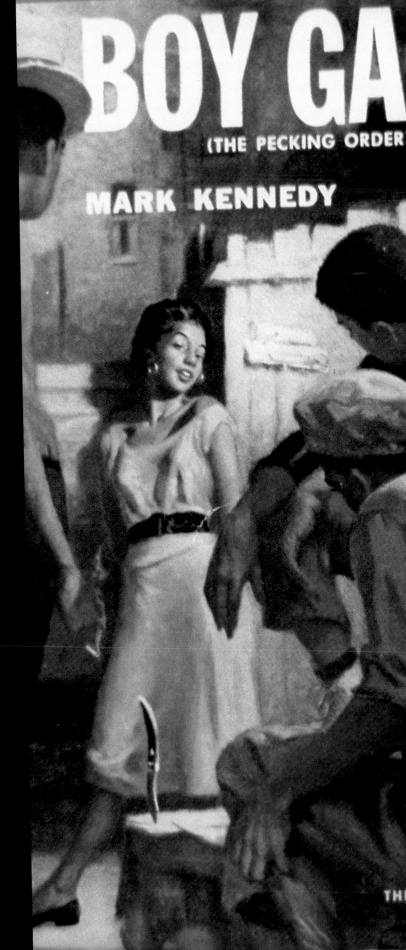

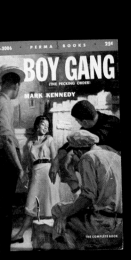

buying more pieces. You wouldn't do that to me, would you? We could do so good together. I like your looks. I like your looks good enough to put out right here on the table for ya. . . Oh, that goof ball is hitting me. Get me outa here quick. Something was wrong. . . with that. . . benny." She slumped over the table, scattering French fries in Rick's lap.

Opposite and right:
More examples of the three-hundred-plus juvenile delinquent paperbacks published in a ten-year period.

Bottom right: *A late entry in the jd genre.*

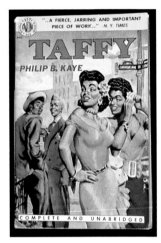

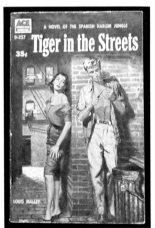

A number of writers came to specialize in teen delinquent stories, including De Roo, Wenzell Brown, Albert Quandt, and Joe Weiss, a mixed bag of social workers, journalists, and former gang members among them. And this being a wide-open market, there were jd authors with no personal connection to the material—William Cox, for instance, who wrote the terrific *Hell to Pay* (*"Kids with ducktail hairdos and tight pants who live on marijuana and the big H and glory in viciousness."*), was a middle-aged ex–pulp writer and drinking buddy of Buster Keaton, unlikely to have had any recent experience as a youth gang member.

The later jd books were pumped up with more outlandish premises , teen crime syndicates taking over the nation and that sort of thing, a far cry from the gritty social realism of *Tomboy* or *The Golden Spike*. Interest in juvenile delinquent stories faded in the early 1960s, a result of urban renewal, changing youth culture, and lack of readers. The last really popular jd paperback was a novelization of the movie musical *West Side Story*—the author, Irving Shulman. The hard-won image of the American delinquent had been co-opted by a Broadway choreographer and after that no one had the will to go on.

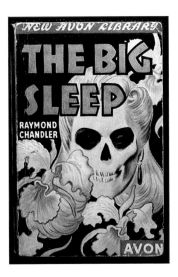

Collecting
Paperbacks

There have probably been collectors of paperbacks since the appearance of the first paperback, more than five hundred years ago. As an organized pursuit, however, the collecting of softcover books is a quite recent development. When the first Pocket Books went into circulation in 1939, inaugurating the modern age of mass-market paperback publishing, there was likely some collector interest due to the

Above and left: The early Avon reprints of Raymond Chandler's stories are highly collectible today.

historical nature of the releases. But this interest quickly faded as paperbacks were relegated to their niche as mere cheap reprints of "legitimate" hardcover editions.

In the lurid years after World War II, the only organized attention paid to the paperback book was by incensed moral watchdogs. Even in the 1950s, when softcover publishers began turning out original material by established and distinctive new authors, these "first editions" went uncollected by libraries and conventional bibliophiles. It is due only to chance and reader interest that any copies still exist of first appearances of works by Burroughs, Dick, Himes, and other now-honored authors. To this day, the majority of rare and antiquarian book dealers cast a skeptical eye at softcover publications.

Paperback collecting therefore began as an underground movement, blissfully lacking any formal guidance or approval. The first real ground swell of activity was in the 1960s. Some people were simply trying to find copies of favorite hard-boiled or science fiction writers who had long gone out of print. Others were influenced by the decade's trendy fixations with pop culture, nostalgia, and "camp."

By the mid 1970s, this interest had developed into a national network of collectors and dealers specializing in vintage paperbacks. At the same time certain early softcover titles and authors had attracted growing cult followings, and museums in the United States and Europe were holding exhibits of cover illustrations by vintage paperback artists.

In 1980, the first paperback price guide was published, listing the great majority of all early American paperbacks, categorized by publisher and offering estimated values according to condition. The book served to turn a relatively haphazard hobby into something like a science, and it made a lot of folks suddenly conscious of the treasures they had

Opposite: A back-of-the-book ad for upcoming masterpieces from Leisure Library.

Below left: Books with black or other racial subject matter make up a thriving subcategory of paperback collector interest.

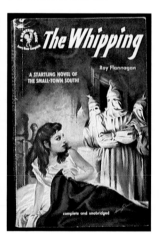

Above right: Lurid and outlandish cover art increases the value of any vintage softcover book.

■ WATCH FOR THESE NEW TITLES ■
NEVER BEFORE PUBLISHED IN THE U. S. A.

THIS WAY FOR HELL
Spike Morelli

The road to Hell is paved with good intentions and people were getting there doggoned fast. Tough international spy-ring comes up against still tougher private-eye. Beautiful seductive ring-leader fails to win last trick.

Three hot dames from the sticks hit Chicago looking for suckers to support

HOT DAMES ON COLD SLABS
Michael Storme

them in the way to which they were never accustomed. How they got their suckers and what happened to them among the tough guys of the underworld makes good reading.

NO PRUDE
Jules-Jean Morac

Parisian photographer's model can never be a prude—at least not for long. Embroiled with dope and stolen gems, young model leads life of luxury, sensualism and vice. Vicious sadism finally blows the top off racket. Real excitement on every page.

ASK YOUR DEALER FOR THESE NEW TITLES

by *Leisure Library, Inc.*

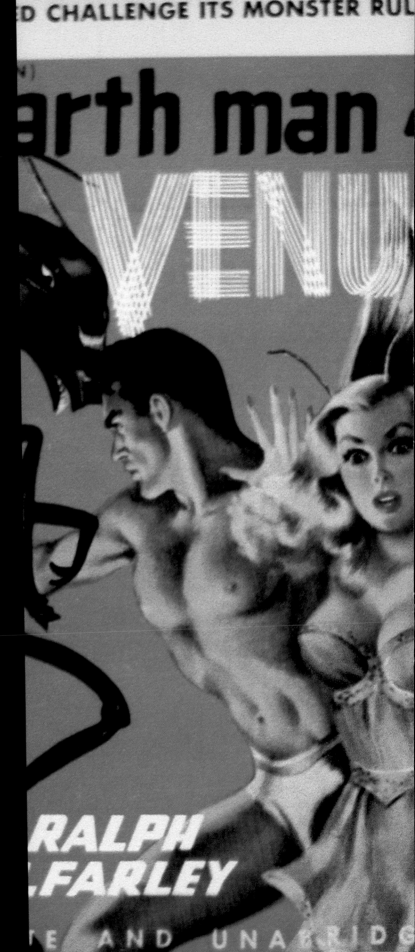

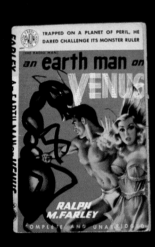

"Trapped on a
planet of peril,
he dared
challenge its
monster ruler"

stacked away in cobwebbed basements and garages.

Today, paperback collecting is well established, with numerous dealers in various countries. These dealers regularly issue catalogs of their vintage stock, and some hold telephone auctions for scarce items. There are now several annual paperback conventions in the United States and Great Britain and a number of publications devoted to the hobby.

Opposite and right: Early science fiction paperbacks are much sought after by collectors.

The increasing traffic in old paperbacks has meant a steady, sometimes astounding rise in prices as more people vie for the same rare items. On the bright side, the bounty on softcover collectibles has put many more books on the market than were thought to exist ten years ago.

The collecting of paperbacks is approached in a number of ways. Some collectors try to track down everything published by a certain author, while others hope to amass all books from a particular imprint—Gold Medal, say, or Ace "doubles"—or in a certain genre. Many collectors are primarily interested in the cover art wrapping the old paperbacks, and they collect by artist or subject matter. A number of collectors gleefully pursue these postwar publications for their over-the-top sensationalism, particularly the lewd, racist, and otherwise outrageous titles, blurbs, and illustrations.

A critical factor in the value of paperback collectibles is the condition of a book, generally rated as Poor, Good, Very Good, or Fine/Mint. Since paperbacks were considered cheap, ephemeral merchandise, they did not tend to be handled with care, and those lasting forty and fifty years in mint condition are rare enough to increase their value by as much as a hundred times over a copy valued as Good. Of course, a hotly collected title in Good condition can still be worth much more than a Mint copy of a book in which no one is currently interested. Increasingly, serious collectors do not

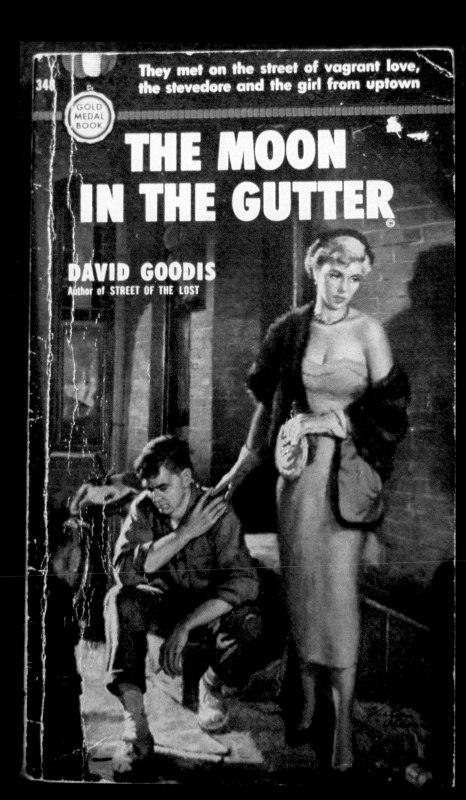

They met on the street of vagrant love,
the stevedore and the girl from uptown

GOLD MEDAL BOOK

348

THE MOON IN THE GUTTER

DAVID GOODIS
Author of STREET OF THE LOST

deal with any books not solidly Very Good or better.

Investing in vintage paperbacks can be a tricky business. An author can become "hot" for a time and then cool down, decreasing the value of his or her books. Winning bids at the more competitive auctions are often considerably above a book's real worth. On the other hand, various "key" paperbacks—the original of Burroughs' *Junkie*, for instance, or the Dell Ten Cent edition of *Marihuana*—are almost certain to maintain or increase their value for as long as there are paperback collectors. The best advice to a prospective new collector is to buy what you like to read or look at, and in the best condition you can afford.

Opposite: The early paperback originals by David Goodis have been steadily increasing in value for over a decade.

Right: Many "key" paperback collectibles were issued by small and short-lived publishing houses.

"TURN OU
THE LIGHT

I kissed her hard, tasting th
marijuana that clung to hei
"I'm scared, Jim," she mur
soft and Mexican. Her body
my hands. "You're safe hei
killers don't know where th

Epilogue

Fate was not kind to the majority of the paperback writers discussed in these pages. In their heyday, barred from critical recognition or fame, they at least had the satisfaction of a large readership and steady market. When many titles were selling over a million copies and Hollywood was routinely buying movie rights to softcover originals, some writers also had a good income.

Times and tastes changed in the field of pop fiction, however, and many top-selling writers of the 1950s found themselves out of print and forgotten in the 1960s and 1970s, their new work rejected

Above: Philip K. Dick toiled in the paperback ghetto for years with little recognition.

Left: Part of a lurid extract from a 1950's paperback.

as "not suitable for the current market." Only a few of the early paperback pros experienced the enviable upward trajectory of a John D. MacDonald, reputation and readership increasing with each passing decade.

Of course, tides turn more than once, and many of these same neglected writers of four decades ago—Jim Thompson, Harry Whittington, Goodis, Himes, and others would undergo a second reversal of fortune: rediscovery by critics, collectors, cultists, and eventually by publishers and film producers sniffing out a trend; windfalls of unexpected royalties and movie money for forty-year-old books; reps readjusted up there with an earlier generation of pop fiction masters. Some of these writers even lived to see it happen. Some didn't.

But that, as they say, is another story.

Below: A back-of-the-book photo ad for some adults-only literature.

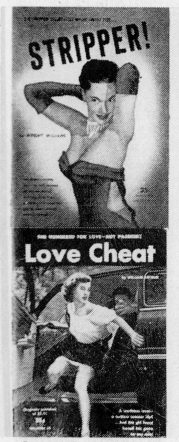

Acknowledgments

I wish to thank the following for their help or services rendered in the creation of this book:

Betsy Willeford, Hal Ellson, Marijane Meaker (a.k.a Vin Packer), Mrs. Harry Whittington, James Avati, Stanley Meltzoff, Dean Server, Mickey Spillane, Allen Ginsberg, Terry Southern, Terri Hardin, Roslyn Targ, Charlotte Stone, David Hitt, Nancy Hitt Gooding, Tedd Thomey, Roy Campbell, William Campbell Gault, Bruno Fischer, Robert Rosenthal, Jaqueline Gens, the University of Florida, Gainesville, George Eastman House, Rochester, New York, Gary Lovisi and *Paperback Parade, Books are Everything*, River Oaks Books, Wayne Mullins, Keith Dilbone, Pandora's Books, Attic Books, Electric Sheep Books, and Black Ace Books.

Bibliography

BOOKS

Bonn, Thomas. *Undercover*. New York: Penguin, 1982.

Burroughs, William (Introduction by Allen Ginsberg). *Junkie*. London: Penguin, 1977.

Garnier, Philippe. *La Vie En Noir Et Blanc*. Paris: Editions Du Seuil, 1984.

Girodias, Maurice, ed. *The Olympia Reader*. New York: Grove Press, 1965.

Hancer, Kevin. *The Paperback Price Guide*. Cleveland, TN: Overstreet, 1980.

Himes, Chester. *My Life of Absurdity*. New York: Doubleday, 1976

McCauley, Michael J. *Jim Thompson: Sleep With the Devil*. New York: Mysterious Press, 1991.

Miles, Barry. *Ginsberg*. New York: Simon and Schuster, 1989.

Morgan, Ted. *Literary Outlaw*. New York: Henry Holt, 1988.

Nicosia, Gerald. *Memory Babe*. New York: Grove Press, 1983.

O'Brien, Geoffrey. *Hardboiled America*. New York: Van Vostrand Reinhold, 1981.

Schreuders, Piet. *Paperbacks, U. S. A.* San Diego, CA: Blue Dolphin, 1981.

Solomon, Carl. *Emergency Messages*. New York: Paragon House, 1989.

Whittington, Harry (Introduction by Whittington). *Forgive Me, Killer*. Berkeley, CA: Black Lizard, 1987.

PERIODICALS

Bad Seed, P.O. Box 646, Cooper Station, New York, NY 10003

Beat Scene, 27 Court Leet, Binley Woods, Nr Coventry CV3 2JQ, England

Books Are Everything, Richmond, Kentucky 40475

Paperback Forum, New York.

Paperback Parade, PO Box 209, Brooklyn, NY 11228-0209.

Index